FRIDA KAHLO *and* SAN FRANCISCO

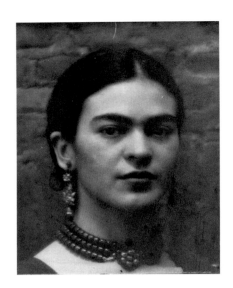

FRIDA KAHLO *and* SAN FRANCISCO

Constructing Her Identity

Circe Henestrosa and Gannit Ankori

with Hillary C. Olcott

de Young \
\ Legion of Honor

fine arts museums
of san francisco

HIRMER

Dedication

In memory of

Zvi Ankori,

Mario Alejandro Henestrosa,

and

Noris Henestrosa

with love

Contents

Foreword

San Francisco played a significant role in shaping Frida Kahlo's self-fashioned identity and launching her artistic path. Her first visit, from fall 1930 to spring 1931, was transformative. It set her on the path that would lead her to become a sophisticated woman, a self-made fashion icon, and a brilliant painter. Her second trip, nearly ten years later, was also momentous. Kahlo, divorced from Diego Rivera and an artist in her own right, returned to the city at the end of 1940. There she underwent a medical procedure with her long-standing doctor and remarried Rivera at San Francisco's City Hall.

Frida Kahlo and San Francisco: Constructing Her Identity celebrates the special affinity that the artist had for our city—and the impression the city left upon her even after she departed from it. We are delighted to have the opportunity to explore this topic in connection with our exhibition *Frida Kahlo: Appearances Can Be Deceiving*, which examines Kahlo's diverse modes of creativity by drawing from the remarkable trove of personal items found at her lifelong home, La Casa Azul (the Blue House) in Mexico City. Locked away following her death in 1954 at the instruction of her husband, Rivera, these materials provide a glimpse into Kahlo's intimate world, and they reveal—through photographs, letters, jewelry, and exceptional garments—the ways in which politics, disability, and national identity informed Frida Kahlo's life, her self-expression, and her bold and uncompromising art.

The exhibition was first presented in 2012 at the Museo Frida Kahlo in Mexico City, and it inspired the 2018 exhibition *Frida Kahlo: Making Her Self Up* at the Victoria and Albert Museum in London. Given Kahlo's unique relationship to the City by the Bay, it is especially fitting that the exhibition is now installed at the Fine Arts Museums of San Francisco. Moreover, the Museums welcome Kahlo back to our galleries: the double portrait *Frieda and Diego Rivera* (1931) hung at the Legion of Honor in the *Sixth Annual Exhibition of the San Francisco Society of Women Artists* in November 1931.

This extraordinary cultural event would not be possible without the support and enthusiasm of Carlos Phillips Olmedo, general director of the Museos El Olmedo, Frida Kahlo y Diego Rivera-Anahuacalli, and Hilda Trujillo, director of the Museos Frida Kahlo y Diego Rivera-Anahuacalli, Mexico City. We also thank the trustees of the Fideicomiso Museos Diego Rivera and Frida Kahlo: Jessica Serrano, Luis Rodrigo Saldaña, and Luis Alberto Salgado. We are further grateful to the incredible work of fashion scholar and independent curator Circe Henestrosa, who served as the guest curator of the exhibition. Gannit Ankori's original scholarship about Kahlo's art, life, and legacy was also invaluable to this project, and we are so appreciative of her participation as an advising curator. We also thank Hillary C. Olcott, associate curator of the arts of Africa, Oceania, and the Americas at the Museums, for serving as the coordinating curator for the de Young presentation.

The project in San Francisco has been realized due to the tremendous generosity of our donors who have helped to foster Kahlo's artistic legacy at our Museums and beyond. We wholeheartedly thank John A. and Cynthia Fry Gunn, Diane B. Wilsey, The Bernard Osher Foundation, The Michael Taylor Trust, the Ray and Dagmar Dolby Family Fund, and George and Marie Hecksher. Additional support is provided by Alec and Gail Merriam.

The Fine Arts Museums are immensely proud to serve as the only West Coast venue for this exhibition and to bring Frida Kahlo back to San Francisco. It is a joy to share with our audiences the art and image of one of the most iconic artists of our time.

THOMAS P. CAMPBELL
Director and CEO, Fine Arts Museums of San Francisco

Preface

FRIDA KAHLO IN SAN FRANCISCO: A HISTORY OF A CONTEMPORARY PRESENCE

Dressed as a Tehuana with an exuberant hairstyle and bold accessories, Frida Kahlo was an attraction for passersby, photographers, and artists alike in all of the cities that she visited: Detroit, New York, Paris, and, of course, San Francisco. In the latter, the painter made two extended trips: from November 1930 to May 1931 and from September to December 1940. In San Francisco, Kahlo showed her own identity and forged the artistic life for which she is renowned today.

San Francisco is currently the venue for the exhibition *Frida Kahlo: Appearances Can Be Deceiving*, which originated at La Casa Azul (the Blue House), now the Museo Frida Kahlo, in Mexico City. The show comprises dresses, accessories, and intimate belongings of the eminent artist. At the prestigious Fine Arts Museums of San Francisco, the presentation is uniquely varied to allow visitors to appreciate Kahlo's conscious making of her own self, taking as starting points her mixed ethnic diversity, her physical disability, and her love of Mexico. Through this display of her garments and other personal effects, we get to know how Kahlo looked, particularly in this beautiful California city in the 1930s.

As we contemplated this exhibition, it became clear that Kahlo's passion for her Mexican roots did not deter her from incorporating her European heritage—from her German father, Guillermo Kahlo, as well as her maternal grandmother, who was of Spanish origin—into her art and persona. These themes we think will especially resonate in a city as diverse and vibrant as San Francisco. Although the aesthetics of her native country predominate in Kahlo's attire, the artist's versatility undeniably led her to form an eclectic style all her own.

One of the most valuable aspects of this exhibition is the opportunity to generate dialogue, knowledge, and research regarding the presence of Frida Kahlo in San Francisco. To this end, we are able to honor and reconstruct her history in the same locale where it took place. I especially thank director and CEO at the Fine Arts Museums of San Francisco, Thomas P. Campbell for his vision to bring Kahlo back to this extraordinary city. I also express my appreciation to Krista Brugnara, director of exhibitions, and the entire staff at the Museums and at the Museo Frida Kahlo for their assiduous work in the preparation of the exhibition. Presenting *Frida Kahlo: Appearances Can Be Deceiving* in San Francisco offers a wonderful continuity to the international admiration of the original textiles and accessories that characterize the Frida Kahlo that we all know today.

CARLOS PHILLIPS OLMEDO
General Director, Museos El Olmedo, Frida Kahlo y Diego Rivera-Anahuacalli, Mexico City

FROM MADAME RIVERA TO FRIDA KAHLO:
TWO SEASONS IN SAN FRANCISCO AND TEN YEARS IN BETWEEN

Madame Rivera, Frida Kahlo, arrived for the first time in San Francisco in 1930. She was twenty-three years old and newly married to Diego Rivera, who was already a famous muralist. Rivera traveled to the city at the invitation of William Gerstle, president of the San Francisco Art Institute (SFAI), and sculptor Ralph Stackpole, who wanted Rivera to paint a mural at the SFAI. According to the painter Lucile Blanch, who, along with her husband, the artist Arnold Blanch, lived in the same building as Kahlo and Rivera, Kahlo was fairly timid. In an interview, Lucile described her as follows: "Frida did not present herself as an artist and was too shy about her paintings to ask me to see them. We were both painters, but we didn't talk about art. We felt like a couple of teenagers. Her words twinkled; she made fun of everything and everyone and laughed playfully and maybe haughtily. She became very critical when she thought something showed too many pretensions, and often mocked the inhabitants of San Francisco."

During this time, Kahlo forged an irreverent, provocative, and ironic character, as described by Blanch and verified by the letters found in her former home, La Casa Azul (the Blue House), in Mexico City. Dressed in a huipil, petticoats, and a silk rebozo, wearing fancy necklaces and gold earrings from Oaxaca with pre-Hispanic carvings or designs of her own, Kahlo walked the streets of San Francisco; cars would even stop as their passengers stared at her.

Kahlo's time in the city can be revisited due in part to the documentation and objects found in the bathrooms, trunks, wardrobes, and drawers of La Casa Azul: approximately three hundred garments, pieces of jewelry, and personal items, as well as almost six thousand photographs, twenty-two thousand documents, and some drawings by Kahlo, Rivera, and other artists. Because of these primary sources, it is possible to learn exciting new aspects about a significant part of Kahlo's life and become more intimately acquainted with this artist and her husband whose legacies today enjoy worldwide recognition. The Casa Azul treasures are on view for the first time in San Francisco in the exhibition *Frida Kahlo: Appearances Can Be Deceiving* at the de Young.

When Kahlo returned to San Francisco in 1940 for medical treatment from Leo Eloesser (her "*doctorcito*"), she encountered a city that had grown exponentially in the intervening ten-year period, including, for example, the completion of two emblematic new bridges: the Bay Bridge and the Golden Gate Bridge. What happened to the life of Kahlo and Rivera during that time? What happened in the world in that decade?

The photographs, objects, and documents retrieved from La Casa Azul give an account of that rich period because the house of Kahlo and Rivera had already become a meeting point for many artists, politicians, and intellectuals from around the world. The Museum of Modern Art (MoMA) in New York organized a Diego Rivera retrospective in 1931, where

he presented eight transportable panels with Mexican and American themes. He was the second artist to whom a solo exhibition was dedicated at MoMA; the first was Henri Matisse. Between 1930 and 1931, Rivera made a mural called *Allegory of California* in the Pacific Stock Exchange Luncheon Club building in San Francisco, which shows the wealth of the Golden State. In 1932, Kahlo and Rivera traveled to Detroit, where he painted the *Detroit Industry Murals* at the Detroit Institute of Arts at the invitation of Henry Ford. That same year, Nelson Rockefeller asked Rivera to paint another mural, *Man at the Crossroads*, which was destroyed in 1934 by the businessman himself.

Those ten years constituted a complicated period for the United States as it strove to emerge from the Great Depression by building, industrializing, and moving forward. In Europe, Adolf Hitler closed the Bauhaus, in 1933. Artists took refuge in their villages or immigrated to the United States, Mexico, or Brazil. In 1939, the Spanish civil government fell against Francisco Franco, and most artists and intellectuals took refuge in France, where they were placed in ghettos before they immigrated to other countries, mainly to Mexico. Joseph Stalin's persecutions of his enemies forced Leon Trotsky into exile and, with Rivera's support, Trotsky fled to Mexico. There, he lived in La Casa Azul from 1937 to 1939. Then, Trotsky and his wife, Natasha, moved a few streets away, to the house where he would be assassinated.

In 1938, Kahlo traveled to New York, where she stayed with her lover Nickolas Muray. Later, she voyaged to Paris, invited by the artist André Breton, who organized an exhibition that included her art. The artists Marcel Duchamp and Mary Reynolds also helped her participate in the collective show *Mexique* that took place in the French capital. That same year, Peggy Guggenheim invited Kahlo to exhibit in London, but the beginning of World War II truncated the project. Back in Mexico City, Kahlo divorced Rivera in November 1939. Upon Kahlo's return to the United States, her passport indicated: "Profession: Artist. Marital Status: Divorced." In the passport photo, she appears sophisticated, with a solid personality, traits we can associate with the fact that she had, by this time, become a recognized artist.

She remarried Rivera on December 8, 1940, in San Francisco, where he was invited again to paint a mural as part of the celebrations around the Golden Gate International Exposition. He defined its theme as "Pan American Unity," or the fusion of North and South America. Kahlo also participated in the celebrations and in the exhibition *Twenty Centuries of Mexican Art* at the Museum of Modern Art in New York. Shortly after, she wrote to her doctor: "The remarriage works well." On two ceramic clocks she painted: "1939, the hours fell asleep, 1940 the hours work again," referring to her remarriage with Rivera.

In the archives of La Casa Azul are the objects, photographs, jewels, dresses, books, drawings, and other works that were found in the enclosed spaces after nearly fifty years. A small part of the findings was announced to the public in 2007, and more has since been displayed at the Museo Frida Kahlo and in international exhibitions. Because of these materials, we can see Madame Rivera, accompanying her husband on her first trip to San Francisco, a housewife by profession, wearing, as is now known through this trove and substantiated by letters, out-of-the-ordinary apparel. "She stood out, the prettiest, the only one," wrote Wassily Kandinsky in a letter now housed in the National Library of France. Ten years later, Madame Rivera was transformed into Frida Kahlo in a decade that began and concluded in San Francisco, as is made evident by the treasures of La Casa Azul.

HILDA TRUJILLO
Director, Museos Frida Kahlo y Diego Rivera-Anahuacalli, Mexico City

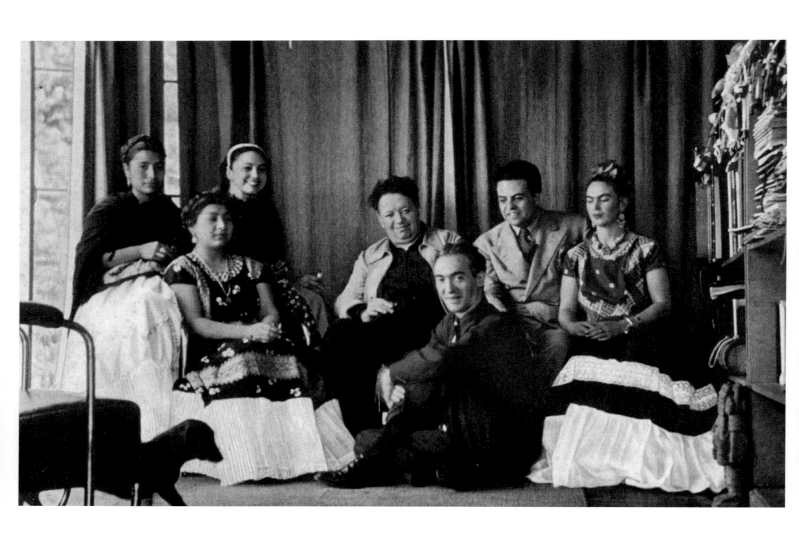

FRIDA KAHLO:
APPEARANCES CAN BE DECEIVING

CIRCE HENESTROSA

Saint, muse, lover, mistress, queer, disabled, victim, and survivor. Frida Kahlo is the very model of the bohemian artist: unique, rebellious, and contradictory—a cult figure appropriated by feminists, artists, fashion designers, and popular culture. From Mexico to San Francisco to New York, Detroit, and later Paris, Kahlo continues to cause sensation with her enigmatic persona.

Writer Carlos Fuentes described how Frida Kahlo's arrival at the Palacio de Bellas Artes (Mexico's Opera House) would be announced by the sound of her jewelry and how the architectural grandeur of the palace, its paintings, and the captivating music of its concerts would be instantaneously outshone by her striking presence.[1] Her image has become so universal that it may seem there was little more to say or learn about Kahlo, but in 2004 a remarkable trove of the artist's personal belongings was unsealed at her lifelong home, La Casa Azul (the Blue House) in Mexico City, opening up possibilities for new research. Locked away at the instruction of her husband, the Mexican muralist Diego Rivera, following her death in 1954, approximately six thousand photographs, twenty-two thousand documents, and, most remarkably, nearly three hundred of Kahlo's personal items—including medicines, orthopedic devices, clothing, jewelry, and accessories—have survived the passage of time.

Born in 1907, Kahlo lived her formative years against the backdrop of the Mexican Revolution (1910–1920), which shaped her enduring commitment to communism. Indeed, she later claimed to have been born the same year the revolution began. At the age of 21 she met, fell in love with, and married Rivera. Their passionate and tempestuous relationship survived infidelities, the pressures of Rivera's career, a divorce and remarriage, and Kahlo's fragile health. She contracted polio at age six and suffered a near-fatal accident at age eighteen, on September 17, 1925. During her long and painful convalescence after the accident, the bedridden teenager began to paint, using a wooden folding easel and a mirror set into the canopy of her four-poster bed. All her life she experienced medical complications, physical limitations, and intense chronic pain. Through her self-portraits and her adoption of indigenous Mexican dress, Kahlo explored her life, her political views, her health struggles, her accident, her turbulent marriage, her gender, and her inability to have children.

1.
Nickolas Muray
Reunion in San Ángel, 1938
Left to right: Alfa Rios
Henestrosa, Nereida Rios,
Rosa Covarrubias, Diego
Rivera, Nickolas Muray, Miguel
Covarrubias, and Frida Kahlo
in San Ángel, Mexico City
Museo Frida Kahlo, Mexico City

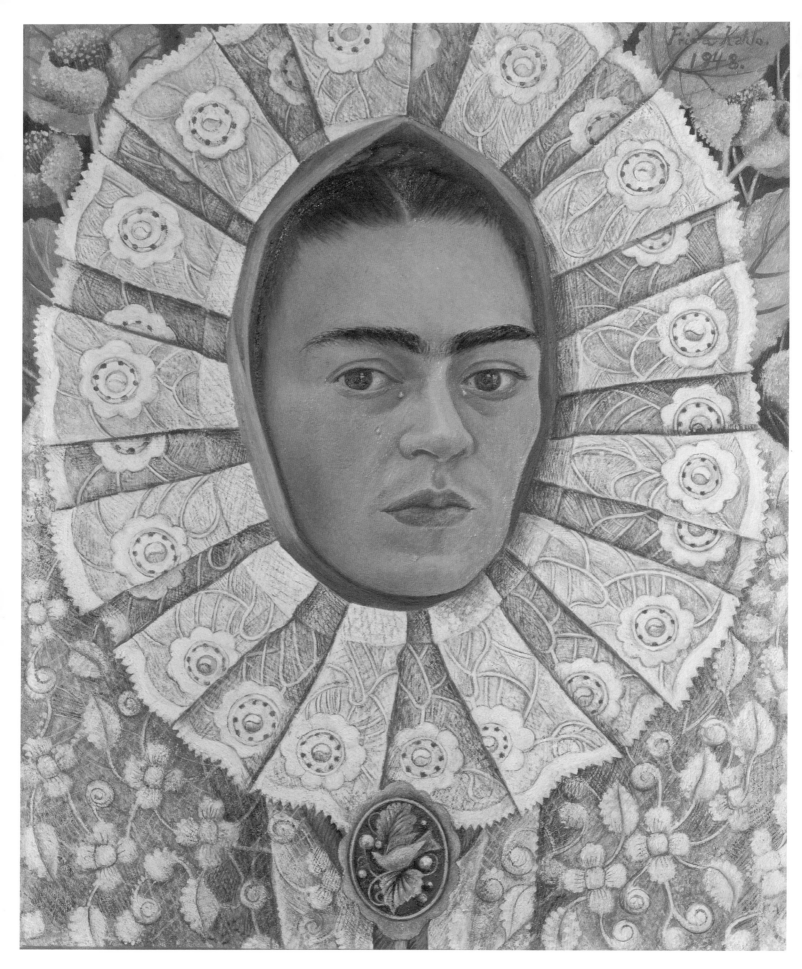

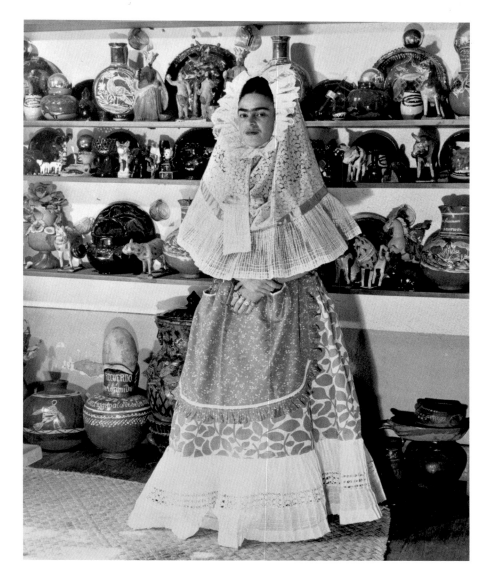

2.
Frida Kahlo
Self-Portrait, 1948
Oil on hardboard,
19 ¾ x 15 ¾ in.
(50 x 40 cm)
Private collection

3.
Bernard Silberstein
Frida Kahlo wearing
a Tehuana costume
(*resplandor* headdress),
La Casa Azul,
Coyoacán, 1940
Private collection

From her death in 1954 until the early 1980s, Kahlo was known mainly as Rivera's wife and her art was practically unknown outside Mexico. During her lifetime she had only two solo exhibitions: one in New York (1938) and one in Mexico (1953). It was not until two decades after Kahlo's death that the first publications about her life would be published—Teresa del Conde's *Vida de Frida Kahlo* (1976)[2] and Raquel Tibol's *Frida Kahlo: Crónica, Testimonios y Aproximaciones* (1977)[3]—but it was with the international publication of Hayden Herrera's book *Frida: A Biography of Frida Kahlo* in 1983[4] that the artist shot to prominence.

Also fueling Kahlo's rise in fame were feminists in the second half of the twentieth century who took her as an example for sexual politics and post-colonial debates.[5] Later, Julie Taymor's 2002 film *Frida* (featuring Salma Hayek); Gannit Ankori's book *Imaging Her Selves* (2002), which

analyzed Kahlo's paintings as deliberate examinations of her constructed identities[6]; and a major 2005 retrospective at Tate Modern, London, followed by many worldwide exhibitions of her work likewise raised her international profile. Today a simple Google search turns up more than forty-six million entries about Kahlo.

With the unlocking of the archive at La Casa Azul, it has become possible to learn more about Kahlo's construction of identity through disability and ethnicity, as well as how she used complementary modes of creativity—painting, photography, and her meticulously composed fashion—to express herself.

As a teenager Kahlo dressed in unconventional ways to express her individuality and hide her damaged leg. In her twenties she embraced traditional Mexican garb and wore

it throughout her life. Although she created a singular hybrid style, mixing elements from diverse regions and periods (garments from Guatemala, China, Europe, and the United States, for example), she especially identified with the indigenous women from the Isthmus of Tehuantepec in the state of Oaxaca in southern Mexico. Prominent Mexican artists and scholars, Kahlo and Rivera among them, were attracted to the isthmus, known for its matriarchal society and rich native culture, that resisted European domination. Although Kahlo never visited the isthmus, she adopted the clothing of the region, creating her iconic self-image as La Tehuana.

Kahlo adopted embroidered blouses, long skirts, elaborate hairstyles, and woven shawls from Tehuantepec as her own mesmerizing version of *mexicanidad* (Mexican-ness) (see figs. 2–3). At the same time, these sartorial choices deflected attention away from her disabilities and injuries. Kahlo donned her outfits as a second skin, transforming them into an integral part of her life, her art, and her identity.

Various scholars have suggested that Kahlo adopted the Tehuana dress to please her husband.[7] When the Casa Azul wardrobe was opened in 2004, however, a photograph of her maternal family reappeared, one that shows Kahlo's mother fully dressed in the Tehuana tradition, consequently revealing Kahlo's relationship with such dress long before she met Rivera. Kahlo's first self-portrait in full Tehuana attire, now in the collection of the San Francisco Museum of Modern Art (SFMOMA), was painted in San Francisco.

It was in San Francisco that Kahlo began to fashion her indigenous (by now instantly recognizable) Mexican identity, deliberately distinguishing herself from the local women.[8] On the streets of San Francisco, children would ask her, "Where is the circus?"[9] and she would just smile graciously and continue walking. Many photographs by Imogen Cunningham, Ansel Adams, Lola Álvarez Bravo, and Edward Weston that show Kahlo as a Tehuana come from the time she spent in San Francisco. It was in San Francisco where Kahlo also met doctor Leo Eloesser, who remained her close friend and medical adviser until her death.

Kahlo depended on medical attention at different stages of her life. Traces of trauma are seen through her orthopedic devices and shoes in the archive (see figs. 4–5). As a result of polio, she was left with a withered and shorter right leg, something that led her to dress in long skirts. From a young age, she began wearing three or four socks on her thinner calf,

4.
Prosthetic leg with leather boot with appliquéd silk and embroidered Chinese motifs, ca. 1954
Museo Frida Kahlo, Mexico City

5.
Frida Kahlo
Diary entry before the amputation of her right leg, ca. 1953
Museo Frida Kahlo, Mexico City

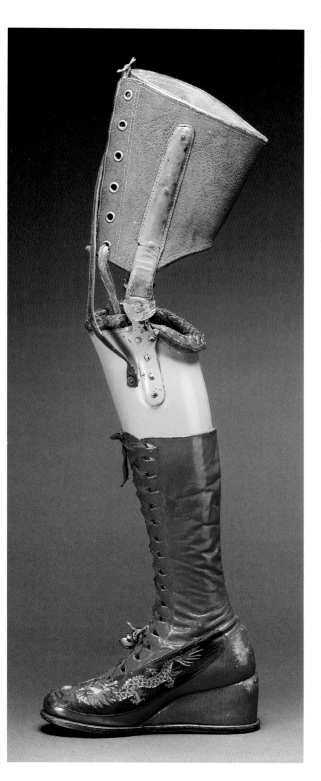

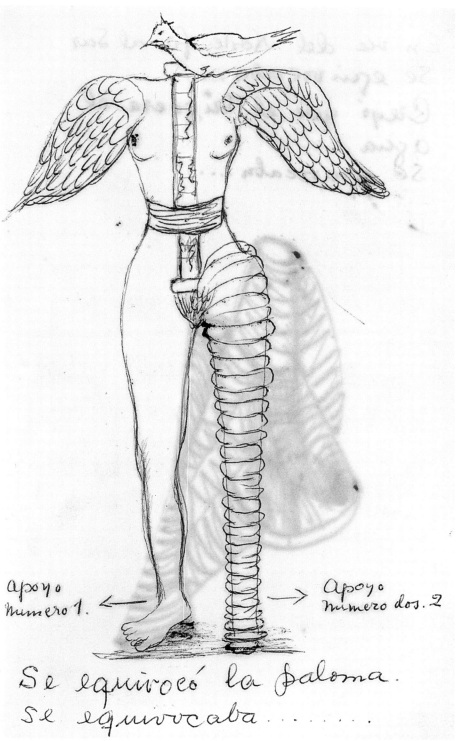

apoyo
numero 1.

apoyo
numero dos. 2

Se equivocó la paloma.
Se equivocaba........

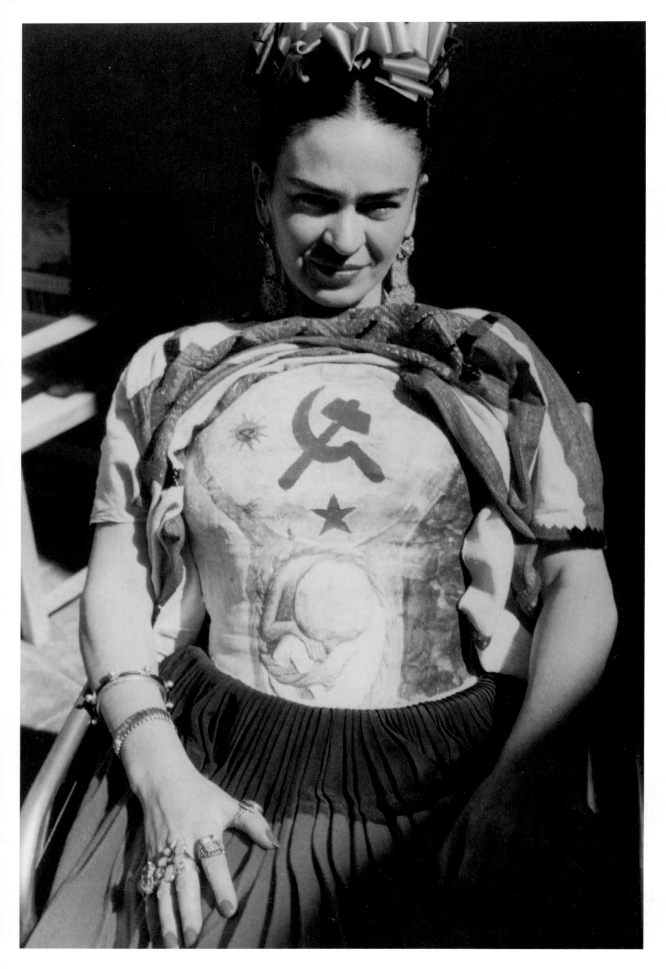

6.
Florence Arquin
Frida Kahlo lifting her *huipil*
to expose her decorated
plaster corset, ca. 1941
Gelatin silver print,
15 x 13 in. (38 x 33 cm)
Throckmorton Fine Art Inc.,
New York

7.
Juan Guzmán
Frida Kahlo with
mirror and paintbrush,
decorating her corset
at the ABC Hospital in
Mexico City, ca. 1950
Gelatin silver print,
9¼ x 7⅜ in.
(23.5 x 18.7 cm)
Throckmorton Fine Art Inc.,
New York

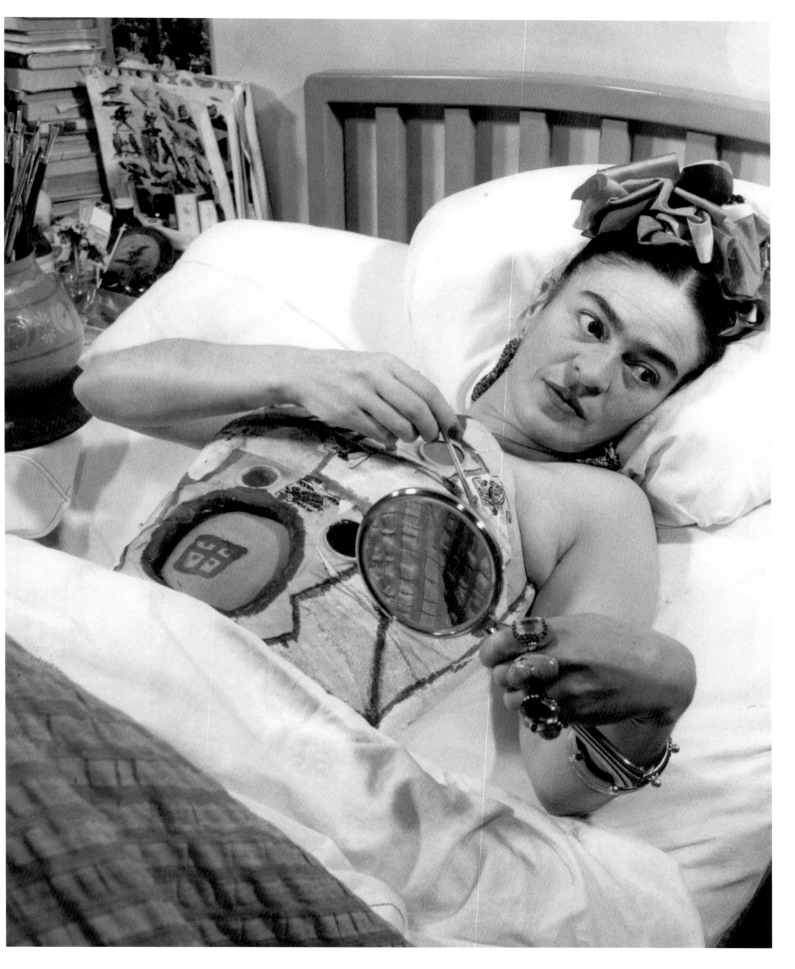

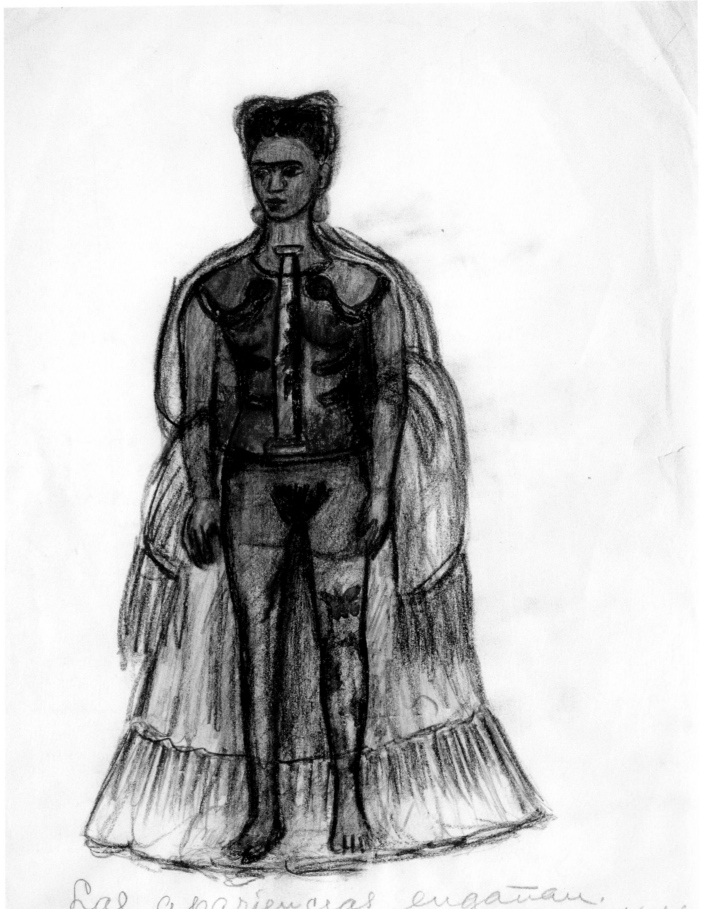

Las apariencias engañan.

Frida Kahlo

and she also wore shoes with a built-up heel to mask her asymmetry.[10] Kahlo would carefully decorate her shoes with bells and pieces of silk covered in Chinese dragon embroideries. There is enough evidence from the correspondence between Kahlo and her parents to show she acquired the Chinese pieces of her wardrobe in San Francisco's Chinatown.[11]

Kahlo also decorated and adorned her corsets, making them appear as if wearing them was a deliberate choice rather than a necessity (see figs. 6–7). She integrated them in the construction of her looks as an essential part of herself, incorporating them into her beautiful Tehuana dresses and uncovering them through her art.

For the Fine Arts Museums of San Francisco presentation, the exhibition title takes its name from a Kahlo drawing titled *Appearances Can Be Deceiving* (fig. 8), discovered at La Casa Azul, that formed the genesis of this project. The modest drawing demonstrates Kahlo's layers of identity not as nostalgia but as a personal manifesto, embodying in one image the complexities that shaped the artist as well as her pieces. Through Kahlo's personal belongings, presented alongside the paintings and photographs that contextualize the findings at La Casa Azul, a more nuanced understanding emerges—not only of Kahlo herself, but also of the ways in which her time in San Francisco influenced her body of work and, consequently, her global persona.

8.
Frida Kahlo
Appearances Can Be Deceiving, ca. 1946
Charcoal and colored pencil on paper
11⅜ x 8¼ in.
(29 x 20.8 cm)
Museo Frida Kahlo, Mexico City

[1] Carlos Fuentes, Introduction to *The Diary of Frida Kahlo: An Intimate Self-Portrait* (New York: Abrams, 1995), 7.

[2] Teresa del Conde, *Vida de Frida Kahlo* (México: Secretaría de la Presidencia, 1976).

[3] Raquel Tibol, *Frida Kahlo: Crónica, testimonios y aproximaciones* (México: Ediciones Cultura Popular, 1977).

[4] Hayden Herrera, *Frida: A Biography of Frida Kahlo* (New York City: Harper & Row, 1983).

[5] Oriana Baddley, Tanya Barson, Emma Dexter, and Gannit Ankori, *Frida Kahlo* (London: Tate Publishing, 2005), 47.

[6] Gannit Ankori, *Imaging Her Selves: Frida Kahlo's Poetics of Identity and Fragmentation* (Westport and London: Greenwood Press, 2002).

[7] Hayden Herrera, *Frida: A Biography of Frida Kahlo* (New York: Harper Perennial, 2002), 111. This is also mentioned in Teresa del Conde's and Marta Turok's contributions to the book *El Ropero de Frida* (Mexico City: Oceano, 2007), by Teresa del Conde, Romero Flores Caballero, Graciela Iturbide, Denise and Magdalena Rosenzweig, and Marta Turok.

[8] Gannit Ankori, "The Poetics of Absence and Silence: Ishiuchi Miyako's Frida Kahlo Photographs." In *Frida by Ishiuchi* by Hilda Trujillo, Gannit Ankori, and Circe Henestrosa (Mexico City: RM, 2014), unpaginated.

[9] Hayden Herrera, *Frida: A Biography of Frida Kahlo* (United States: Harper Perennial, 2002), x.

[10] Hayden Herrera, *Frida: A Biography of Frida Kahlo* (United States: Harper Perennial, 2002), 18.

[11] Unpublished letters, which Kahlo gave her friend Dr. Leo Eloesser in 1953, are part of the Nelleke Nix and Marianne Huber Collection, Betty Boyd Dettre Library and Research Center at the National Museum of Women in the Arts in Washington, DC (NMWA archives). The author thanks Gannit Ankori for sharing some of these letters while completing the manuscript for her book *Critical Lives: Frida Kahlo* (London: Reaktion Books Ltd., 2013, repr. 2018).

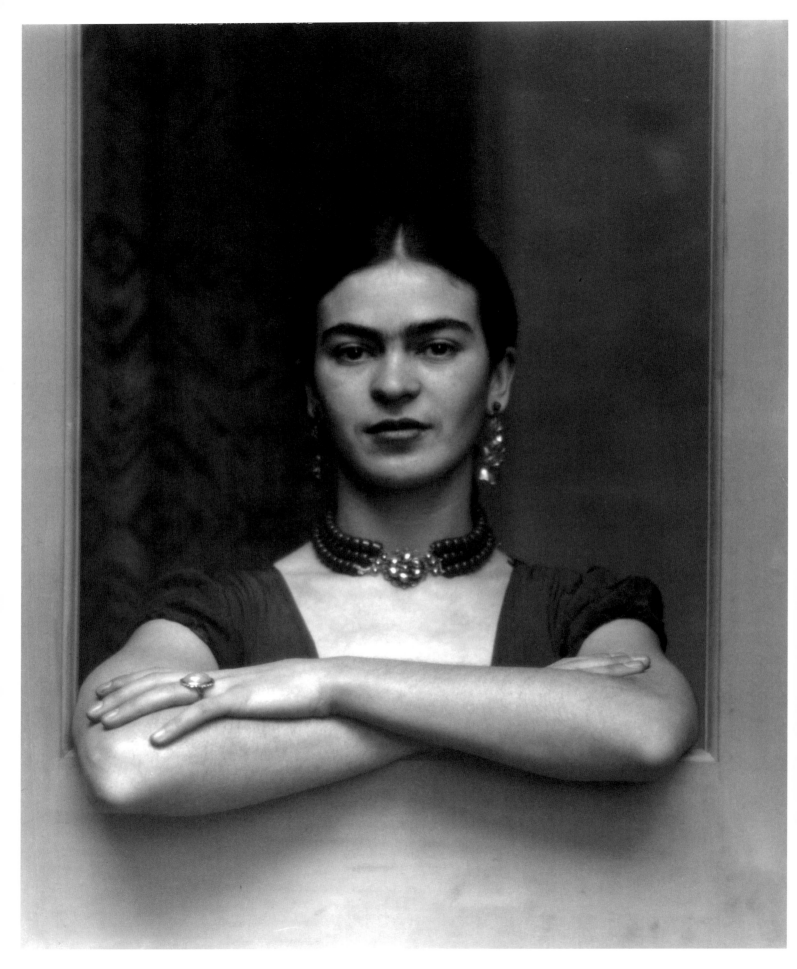

FRIDA KAHLO IN SAN FRANCISCO
"THE QUEEN OF MONTGOMERY STREET"[1]

GANNIT ANKORI

It was in San Francisco that Frida Kahlo (fig. 1) fully embraced her flamboyant Mexican self-image vis-à-vis the "dull gringas," as she referred to the American women she met in the city. She fashioned a distinctive sartorial style from a sumptuous palette of indigenous costumes, beribboned hairdos, and an elaborate assortment of colors, textures, accessories, and jewelry.[2] It was here that she also began to paint more seriously than ever before, to emerge from Diego Rivera's enormous shadow—literally and figuratively—and to establish a place of her own in the spotlight.

Kahlo attained initial public exposure in August 1929 when she became Rivera's third wife.[3] She was twenty-two; he was forty-three. She was just beginning to paint; he was already internationally renowned as an artist of genius, a peer and friend of Pablo Picasso, and one of the three great muralists (Los Tres Grandes, alongside José Clemente Orozco and David Alfaro Siqueiros) spearheading what came to be called the Mexican Renaissance. Rivera and Kahlo's 1929 marriage certificate identifies him as "artist, painter" and her as "housewife."[4] In November 1930, the newlyweds traveled to San Francisco, where Rivera—already a celebrity—was commissioned to paint a mural at the Stock Exchange.[5] This was Kahlo's first time away from her home (and her homeland), and the experience transformed her. Enthralled by the adventures that awaited her, she penned lengthy letters to her family and friends that reflected what she saw and how she was seen.[6]

"San Francisco is very beautiful. . . . For the first time I got to see the ocean and I loved it! The city is in a beautiful location, from everywhere you can see the sea. The bay is beautiful and ships arrive from China and from everywhere in the Orient," she wrote her father (her "*papacito lindo*") with evident glee.[7] Kahlo's letters reflect her intense curiosity and childlike sense of wonder. She explored the ethnic diversity of the city, sharing astute observations with her family: "[San Francisco] has neighborhoods with foreigners from everywhere in the world. In the Russian neighborhood people are dressed like in Russia, and the girls dance in the hills; the Greek and the Japanese neighborhoods are very interesting too." She reported on excursions to Berkeley, Santa Rosa, Fairfax, and Stanford and joyfully recounted her very first plane ride, celebrations of the Chinese New Year, outings with the Chinese ambassador, Rivera's lecture at the Legion of Honor "palace," a screening of "scenes by Chaplin," and a delightful puppet show. She also shared unpleasant encounters, conveyed with severe criticality, such as

finding a drunk man on her doorstep on New Year's Eve and witnessing a segregated, Depression-era walkathon, whereby desperate, and often homeless, participants competed for a cash award and were given shelter and food for the competition's duration.[8] "What a horrible thing!!!" was Kahlo's response to this spectacle. "It's incredibly cruel, as the misery those poor people are in, forces them to do those horrible things. Imagine walking for two months!" The contest that Kahlo saw included African American contestants, which compounded poverty with racial discrimination.[9]

Appalled by the ruthlessness of the US capitalist system, the growing wealth gap, systemic inequalities, and other forms of social ills that she observed, Kahlo was drawn to the city's "foreign" and marginalized populations. Above all, she was fascinated by Chinatown and felt a strong affinity with the Chinese inhabitants of San Francisco. In one letter, she suggested that Mexicans and Chinese are "the same people," comparing Chinese aesthetics with her own taste and predilections for exuberant fabrics and handmade embroideries. She went on to compare Chinese and indigenous Mexican children, raving about their unparalleled (and to her mind, similar) beauty. She even sought and employed a Chinese seamstress to help her craft her own garments. She wrote her father with palpable excitement: "Imagine, there are 10,000 Chinese here, in their shops they sell beautiful things, clothing and handmade fabrics of very fine silk, when I return I'll tell you all about it in detail."[10] By the time she did return to Mexico (in May 1931), Kahlo had acquired multiple Chinese items, which she would later integrate into her wardrobe (see Henestrosa, fig. 4).

PHOTOGRAPHS OF THE ICONIC "FRIDA"

While she was attentively surveying her new surroundings, Kahlo was no less aware of how she was perceived by those around her. Her letters trace a growing understanding of the power of distinct ethnic costumes that seems to have stimulated further development of her own indigenous Mexican look. Away from her homeland, her native

costumes and sartorial flair were a rare and much-admired phenomenon, as she wrote her mother with pride and joy: "The gringas really like me a lot and pay close attention to all the dresses and rebozos that I brought with me, their jaws drop at the sight of my jade necklaces and all the painters want me to pose for them."[11]

Kahlo did indeed pose in San Francisco, but exclusively for photographers, not painters. In fact, the image of "Frida" that has become so well known today predated her own self-portraits and may be viewed as a close artistic collaboration between Kahlo and an international host of exceptional photographers. Kahlo's affinity with photography as a medium and her intimate personal and professional relationships with photographers began when, as a toddler, she learned how to strike a pose and direct her intense, unwavering gaze at her beloved photographer-father, Wilhelm (Guillermo) Kahlo.[12] As an adolescent, she also experimented with the medium, taking photographs but also donning a wide array of identity-bestowing costumes and performing various personae for the camera.[13]

In San Francisco, Kahlo had the opportunity to hone the skills she had acquired as a photographer's daughter and his favorite subject. With her penetrating gaze and magnetic appearance, she attracted the finest photographers of the day, among them Peter A. Juley, Ansel Adams, Imogen Cunningham, and Edward Weston (see figs. 1, 2, and 10).

Weston recorded his encounter with Kahlo's riveting presence: "I photographed Diego again and his new wife— Frieda—too: She is in sharp contrast to Lupe [Rivera's ex-wife Guadalupe Marín], petite, a little doll along Diego, but a doll in size only, for she is strong and quite beautiful, shows very little of her father's German blood. Dressed in native costume, even to huaraches, she causes much excitement on the streets of San Francisco. People stop in their tracks to look in wonder."[14]

Kahlo enjoyed being photographed, as she perfected her self-constructed role as La Mexicana. Soon after her arrival

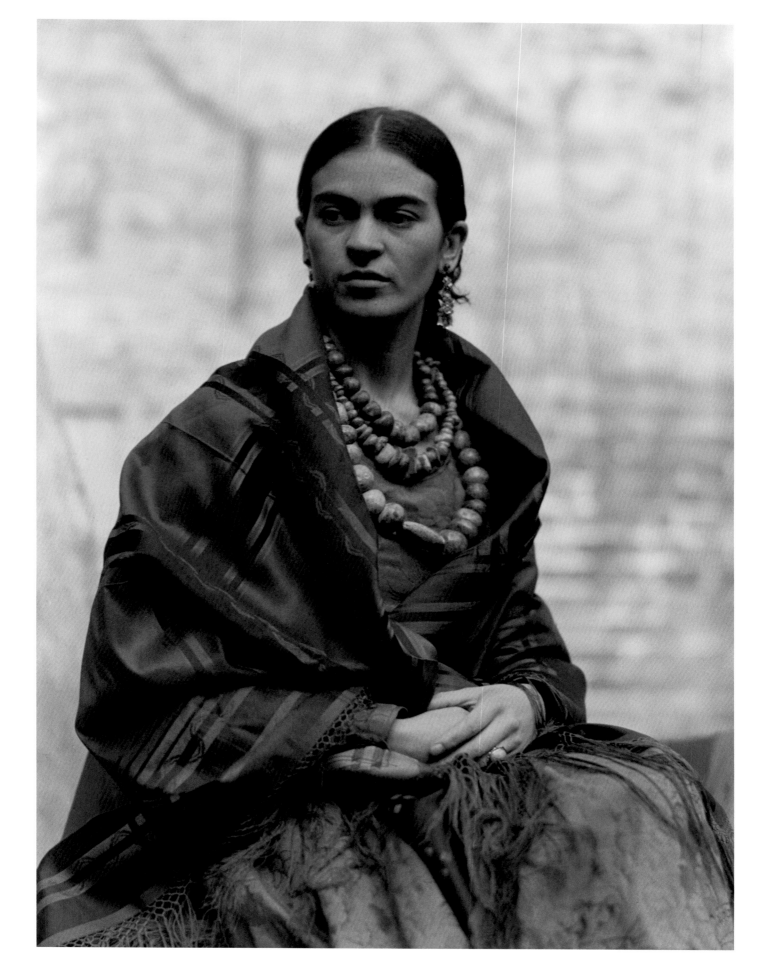

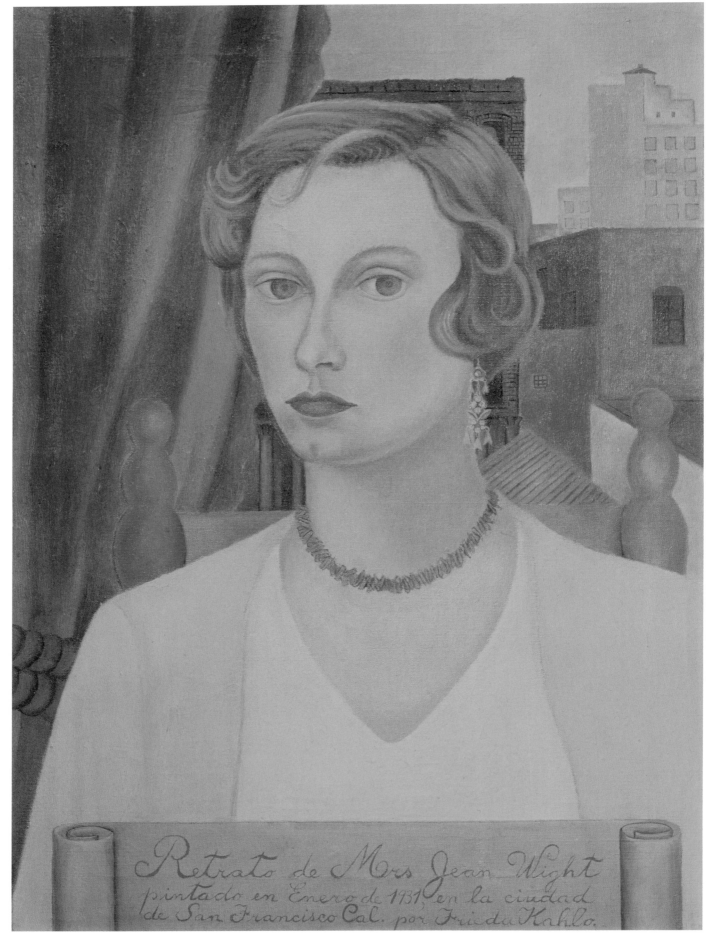

Retrato de Mrs Jean Wight pintado en Enero de 1931, en la ciudad de San Francisco Cal. por Frieda Kahlo.

24

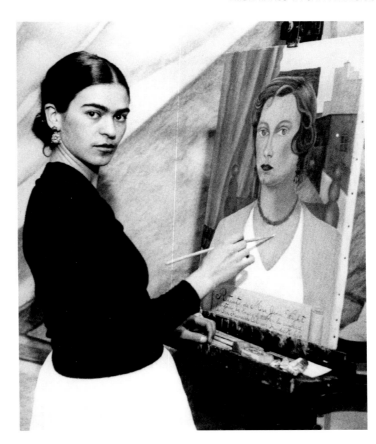

3.
Frida Kahlo
*Portrait of Jean
Wight*, 1931
Oil on canvas,
25 x 18⅞ in.
(63.5 x 47.9 cm)
Collection of Gretchen
and John Berggruen

4.
Frida Kahlo painting
*Portrait of Jean
Wight*, 1931
Private collection

in San Francisco, she wrote her mother: "They took magnificent pictures of me. I'll send you copies as soon as I get them." Some of the photographs were published in the local press and Kahlo clearly relished the attention, writing her mother, "I will send you the newspaper clippings in which we have appeared, please put them in a very safe place for me."[15]

PAINTING PORTRAITS OF HER FRIENDS

Photographers, artists, writers, and other intellectuals formed the lively milieu in which Kahlo thrived. From November 1930 through May 1931, she and Rivera resided at 716 Montgomery Street, San Francisco, amid an avant-garde and close-knit community bustling with creative energy. The place belonged to the sculptor Ralph Stackpole and his French wife, Ginette, a painter. The Stackpoles lived across the hall, hosted Kahlo often, and introduced her to their international circle of friends and collaborators. Among them were the British sculptor Clifford Wight and his wife, Jean, as well as Lord John Hastings (also from the UK) and his Italian-born wife, Lady Cristina Hastings. Both men worked as Rivera's assistants; their spouses spent time exploring San Francisco with Kahlo.[16] Local visitors who came by included William Gerstle, president of the San Francisco Art Institute; architect Timothy L. Pflueger; art collector and patron Albert Bender; art critic Emily Joseph; writer John M. Weatherwax; and photographer Dorothea Lange and her husband, painter Maynard Dixon.

It was Lange who introduced Kahlo to Dr. Leo Eloesser, the man who was to become her closest friend, medical adviser, and soul mate. Lange biographer Linda Gordon identified

the special links between Lange and Kahlo: both were diagnosed with polio as children and hid their withered legs underneath long skirts. Both held strong political convictions and a commitment to social justice. Both were married to older male artists who were unfaithful, dominant, and domineering. Finally, both women were artists in their own right, struggling to find their own creative voice. Gordon concludes, "Dorothea offered Kahlo the use of her photography studio. More important, Dorothea gave her a lifelong gift, one whose value is impossible to overestimate: her doctor, Leo Eloesser."[17]

While Rivera was painting his grand murals in San Francisco in front of an adoring audience, Kahlo wrote her mother that she painted, mainly to keep herself occupied and to avoid "being too sad" or bored. Although these may have been her initial motivations, it is evident that as she painted and sketched portraits of her friends, she developed her craft considerably and even hoped to exhibit her work.[18] Just as her mode of dressing accentuated an overt espousal of *mexicanidad* (Mexican-ness), so too did her pseudo-naive emulation of Mexican colonial portraiture, which included scrolls inscribed in Spanish, plus other tropes, such as the open curtains that frame her subjects.

A painting of Jean Wight, signed and dated on January 1931 (fig. 3), combines an image of a conventional woman (whom Kahlo found plain and often annoying) with a cityscape of San Francisco as seen from Kahlo's window. Photographs of Kahlo painting this work (fig. 4) appeared in the local press, with a derisive quote from Rivera, who dismissed Kahlo's work by claiming not to look at it at all.[19]

At the same time, Kahlo penciled an exquisite drawing, also dated January 1931 (fig. 5). It is a tender portrait of Eva Frederick sitting in an *equipal* chair (a traditional Mexican barrel-shaped chair made of leather and wood) that Stackpole had placed in the apartment room in order to make Kahlo feel at home. Frederick was an African American woman, probably introduced to Kahlo by Imogen Cunningham, who had photographed her beautiful face. Kahlo's drawing presents Frederick nude in a relaxed pose.[20] The same year, Kahlo also painted a glowing bust of Frederick. Although clothed, her accentuated breasts and clearly delineated nipples give her a voluptuous aura (fig. 6). Her eyebrows are fashionably thin, her gaze is alluring, and the unfurled scroll at the top of the composition seems to form hooks that encroach upon the figure as if trying to possess her. The inscription reads, "Portrait of Eva Frederick, born in New York, painted by Frida Kahlo."

The artist's budding interest in African American culture is reflected in her letters: "A few days ago I saw something magnificent at the theater involving Blacks. This is what I have loved the most."[21] This interest, sparked in San Francisco, intensified by the time she arrived in New York, where the writer and photographer Carl Van Vechten photographed Kahlo and Rivera and took them to Harlem several times. He had documented and supported the Harlem Renaissance and its protagonists and must have been an extraordinary guide. Kahlo reported on one visit in a letter dated November 23, 1931: "We went to Harlem, which is the Black neighborhood, we went to see them dance, it was a beautiful thing, and there were

5.
Frida Kahlo
Eva Frederick Nude, Sitting in an Equipal *Chair*, 1931
Pencil on paper,
24½ x 17¾ in.
(62 x 45 cm)
Museo Dolores Olmedo Patiño, Mexico City

6.
Frida Kahlo
Portrait of Eva Frederick, 1931
Oil on canvas,
24⅜ x 17¾ in.
(62 x 45 cm)
Museo Dolores Olmedo Patiño, Mexico City

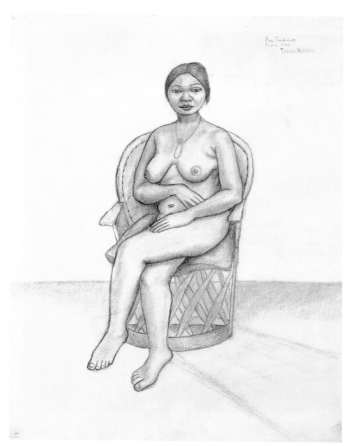

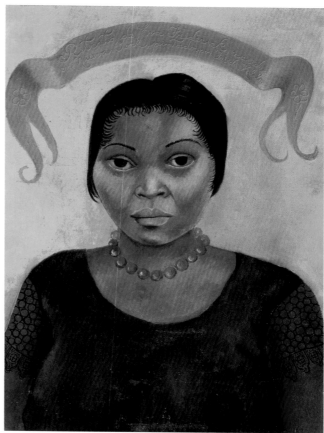

thousands of beautiful mulatto girls, no one in the world dances like them."[22] Later in life, when she visited Paris in 1939, Kahlo apparently befriended the African American dancer, performer, and activist Josephine Baker. There is a photograph of the two women together, but the nature of their association remains a mystery.[23]

EMBRACING HYBRIDITY AND FREEDOM

In addition to painting portraits of her intimate circle of friends, Kahlo produced an original and imaginative posthumous portrait of Luther Burbank, a botanist and scientist from Massachusetts who had settled in California and become internationally famous for crossbreeding, grafting, and hybridizing plants, including flowers, fruits, and vegetables.[24] Based on a photograph that she obtained after visiting his farm in Santa Rosa, California, Kahlo painted Burbank as a hybrid creature: a man, a tree trunk, a philodendron plant, and a cadaver all in one (fig. 7).[25]

In order to fully understand the sophisticated ideological implications of Kahlo's tribute to the late Burbank, a brief reconstruction of several pertinent issues that relate to his life and times is in order. In July 1925, less than a year before his death, Burbank (along with Kahlo and other intellectuals) was shocked by the so-called monkey trials in which John Scopes—a biology teacher in Tennessee—was put on trial and convicted for teaching Darwin's theory of evolution.[26] In reaction to this, Burbank—a great admirer of Darwin since his youth and an avid believer in evolutionary science—publicly proclaimed, "I am an infidel," voicing his opposition to religious tenets and his utter disbelief in life after death. Burbank declared that the only thing that may remain after the body decays is the "immortal influence" of one's good work. His proclamations made the front page of the *San Francisco Bulletin* (January 22, 1926), creating what his biographer described as "shock waves around the world."[27] Although Kahlo arrived in San Francisco several years after Burbank's death, she met his young widow during her visit to Santa Rosa, as well as a number of his friends, and was well acquainted with his legacy. Moreover, the controversies surrounding his work, his conflicts with religious doctrines, and his blasphemous public proclamations were still very much the talk of the town. Well versed in the Bible, both Burbank and Kahlo would have known hybridization and crossbreeding were strictly forbidden in Scripture (for example, Leviticus 19:19). In 1931 Kahlo chose to portray Burbank—who had

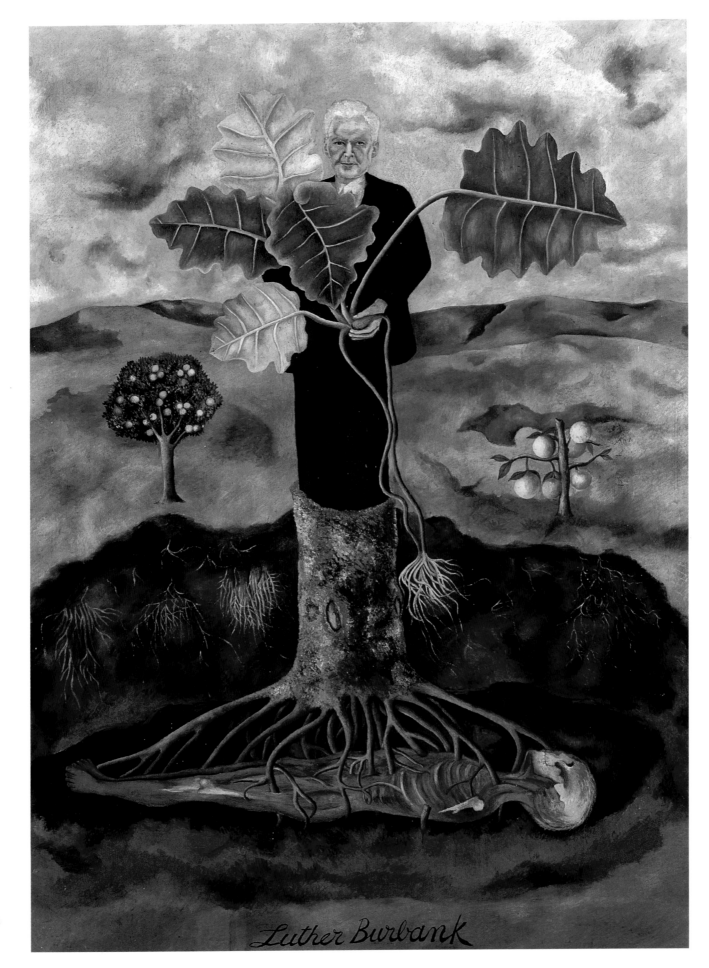

Luther Burbank

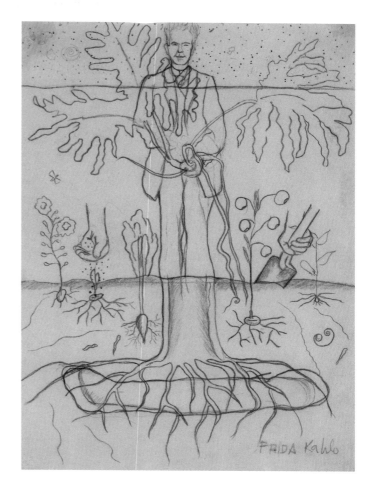

7.
Frida Kahlo
*Portrait of Luther
Burbank*, 1931
Oil on hardboard,
33½ x 24 in. (85 x 61 cm)
Museo Dolores Olmedo
Patiño, Mexico City

8.
Frida Kahlo
Drawing for *Portrait of
Luther Burbank*, 1931
Pencil on paper,
11⅞ x 8½ in.
(30.3 x 21.5 cm)
Colección Juan Rafael
Coronel Rivera, Mexico City

been dead for five years—as a decomposing body planted in the earth, memorializing the creator of hybrids as a hybrid himself and consequently relating his symbolic immortality to the "influence of his good work." Within the dichotomy inscribed by the Bible between purity of "kind"—of seed and species on the one hand, and crossbreeding, mixing, and hybridization on the other—Kahlo clearly chose to embrace hybridity, which is associated here with science, but also with freedom and unbridled creativity.

Kahlo's exploration of hybridity, embodied in her innovative portrayal of Burbank, which she began to pursue in San Francisco, continued to develop throughout her life. Variously expressed in her art and life, it became a staunch ethical position, antithetical to the promotion of "purity" that dominated racial politics and certain social norms of the twentieth century. Kahlo's anti-Nazi worldview, and her unequivocal rejection of all regimes that advocate for racial purity, became central political creeds. Beyond this, the desire to trespass and break multiple conventions and boundaries found poignant expression in her taboo-breaking art.

THE QUEEN OF MONTGOMERY STREET

Kahlo's extraordinary intellectual, artistic, and personal growth in San Francisco was captured by one of her new friends, the writer John M. Weatherwax. Weatherwax was working with the Russian filmmaker Sergei Eisenstein on the film project *¡Qué viva México!* and was asked to approach Rivera to facilitate one of the scenes to be shot on location in Mexico. The two men became friends, collaborated on a project to translate and illustrate the

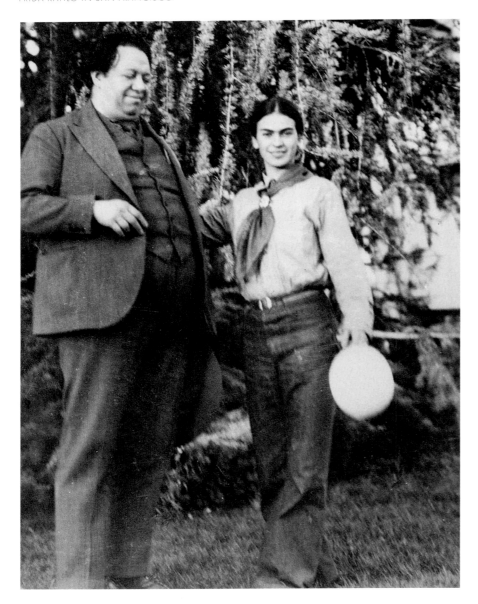

9.
Diego Rivera and Frida
Kahlo in Santa Rosa, 1929
Luther Burbank Home
and Gardens Collection,
courtesy of the Sonoma
County Library

Mesoamerican manuscript Popol Vuh, and shared an infatuation with the exuberant Kahlo. In 1931 Weatherwax completed a dozen versions of an unfinished play and a short story, both titled *The Queen of Montgomery Street*. In these manuscripts, the much-adored "Queen Frieda" comes to life, and her singular persona and dramatic appearance captivate all who come under her spell. (Kahlo added the Germanizing letter "e" to her name at certain points in her life, hence the discrepancy in the spelling.)

> "The Queen has been laughing and clapping her hands. . . . Everyone has been looking at her. She is bewitching in her long, high-waisted, grass-green dress. Over her shoulders is a bronze open-work shawl. About her neck is a heavy jade-green *chalchihuitl* necklace [Chalchihuitl being a goddess of fertility, birth, water, and death]. Her black hair is parted in the middle and drawn into a little knot at the back of her neck. Her cheeks and lips have just the right amount of rouge. Her feet are still in guaraches [huaraches or Mexican sandals]. Glowing, she returns to her seat."[28]

Weatherwax also provides details about Kahlo's portrait painting:

> "The Queen is already hard at work. The poser doesn't crack a smile, doesn't even look up when the door opens. Frieda works like lightning. She has done many oils. If she wished, she could have a one-man [sic] exhibit in New York at any time. . . . At last Don Diego comes home. . . . The Queen throws her arms around his neck, laughing gleefully. Astonishment, fear, and joy struggle in Don Diego's face. The poser bows good-bye. The King and the Queen go to Frieda's gigantic easel. Don Diego looks long and soberly at his wife's work. '*Bueno*,' he says. After a while he adds in Spanish: 'A pure and strong woman's spirit is as precious as the light of the stars.'"[29]

The gaping discrepancy between this supportive statement made by the fictional "Don Diego" and Rivera's dismissive remark quoted in the press is noteworthy. It is difficult to know if Rivera was inconsistent or if only one version reflects his actual attitude toward Kahlo's painting at this point in time.

LOS TRES AMIGOS: KAHLO, RIVERA, AND ELOESSER

While Weatherwax was composing his tender tale of Queen Frieda and Don Diego, Kahlo painted a slightly more ambiguous version of the marriage (fig. 10). The inscription painted above the double portrait reads: "Here you see us, myself Frieda Kahlo, together with my beloved husband Diego Rivera. I painted these portraits in the beautiful city of San Francisco California for our friend Mr Albert Bender, and it was the month of April 1931."[30] Kahlo herself, the artist who painted the image, is not presented as a painter at all. Rather, it is Rivera who is portrayed as the great artist, holding the attributes of the painter—palette and brushes—in his right hand. Kahlo, in contrast, holds on to her husband, defining herself not as a painter but as "the painter's little wife."[31] She displays herself in colorful native garb, adorned with a red rebozo and jade Aztec beads—the paradigmatic Mexican woman. Moreover, Kahlo's manner of painting this work—the stiff pose, awkward rendering of the feet and affinity with colonial portraiture—emulates the style of an amateur painter. She conceals her sophistication behind a mask of naivete and camouflages her position as a painter by espousing the subordinate role of the doting wife. Ironically, Kahlo deliberately based this Mexican pseudo-naive work on a well-known European precedent: Jan van Eyck's depiction of a marriage, his *Arnolfini Portrait* (at the National Gallery in London) of 1434. She kept a reproduction of this work in her studio, among numerous other books and documents that reflect her vast knowledge and erudition. Like van Eyck, she emphasized the importance of the marriage bond by placing the joined hands of husband and wife at the very center of the composition. The exact positioning of Rivera's hand and head, however, subtly conveys his aloofness and less-than-active participation in this union.

Archival sources and collections of Kahlo's published letters demonstrate that she kept in touch with her San Francisco friends over the years, among them Bender, the Wights, and Lady Cristina Hastings.[32] Undoubtedly, however, the most profound relationship she forged in San Francisco was with the thoracic surgeon and medical scholar Leo Eloesser. The two met on November 9, 1930, and the very next day Kahlo wrote to her mother, raving about the doctor. His fluency in Spanish, the way he took care of her, and her complete confidence in him—as a medical doctor and a trusted friend—were transformed into a friendship

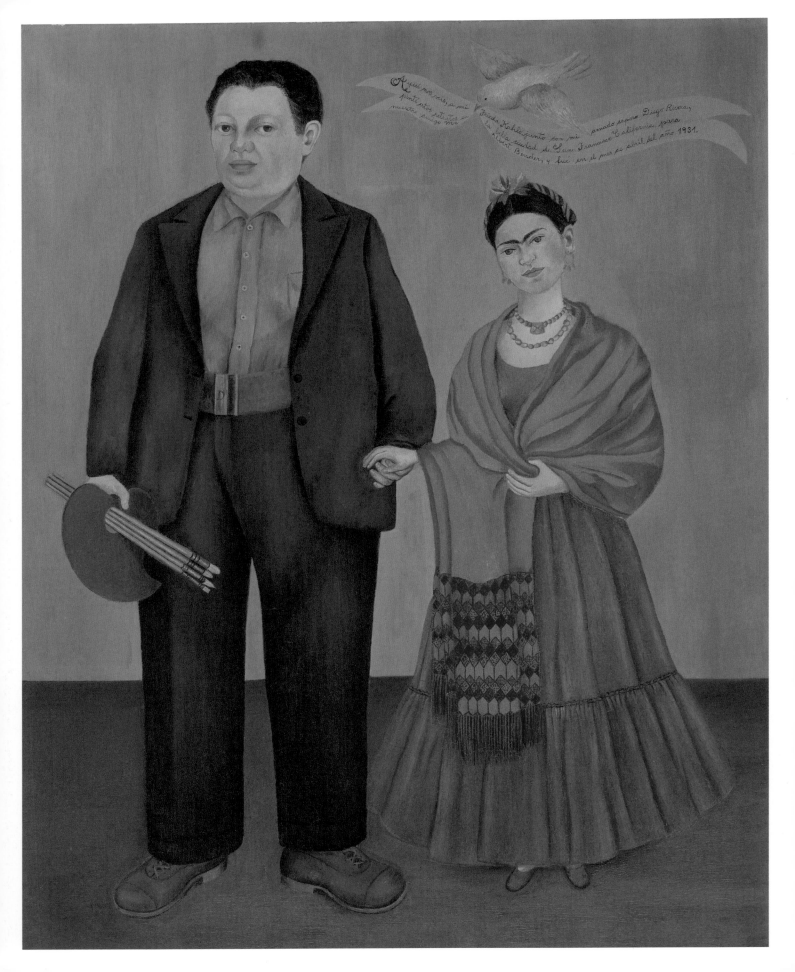

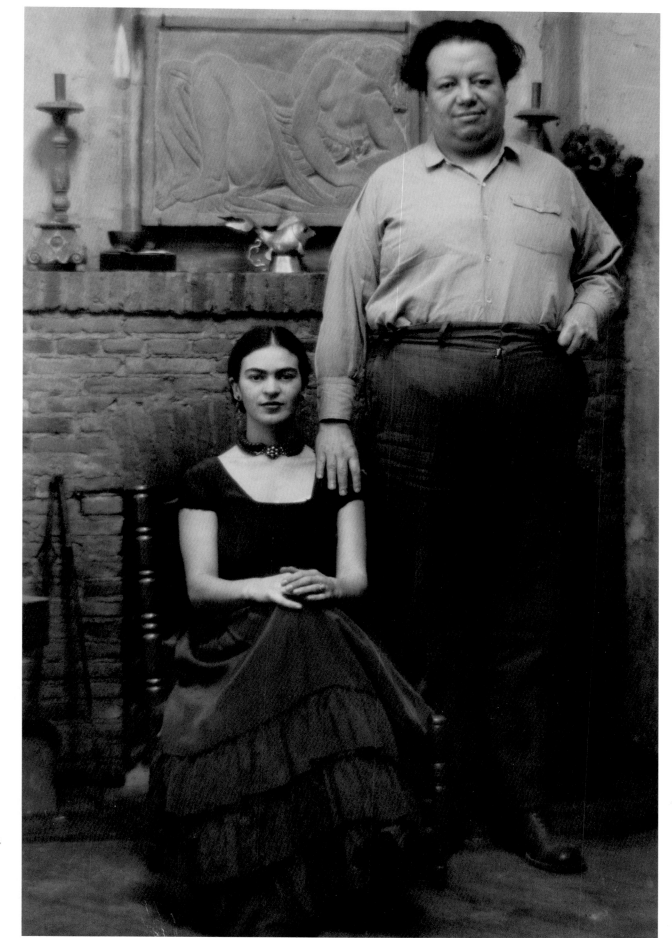

10.
Frida Kahlo
*Frieda and Diego
Rivera*, 1931
Oil on canvas, 39⅜ x 31 in.
(100 x 78.7 cm)
San Francisco Museum
of Modern Art, Albert M.
Bender Collection, Gift of
Albert M. Bender, 63.6061

11.
Peter A. Juley & Son
Diego Rivera and
Frida Kahlo, 1931
Gelatin silver print,
9¾ x 7¾ in.
(24.8 x 19.7 cm)
Detroit Institute of Arts,
Founders Society Purchase,
Diego Rivera Exhibition
Fund, F1986.17

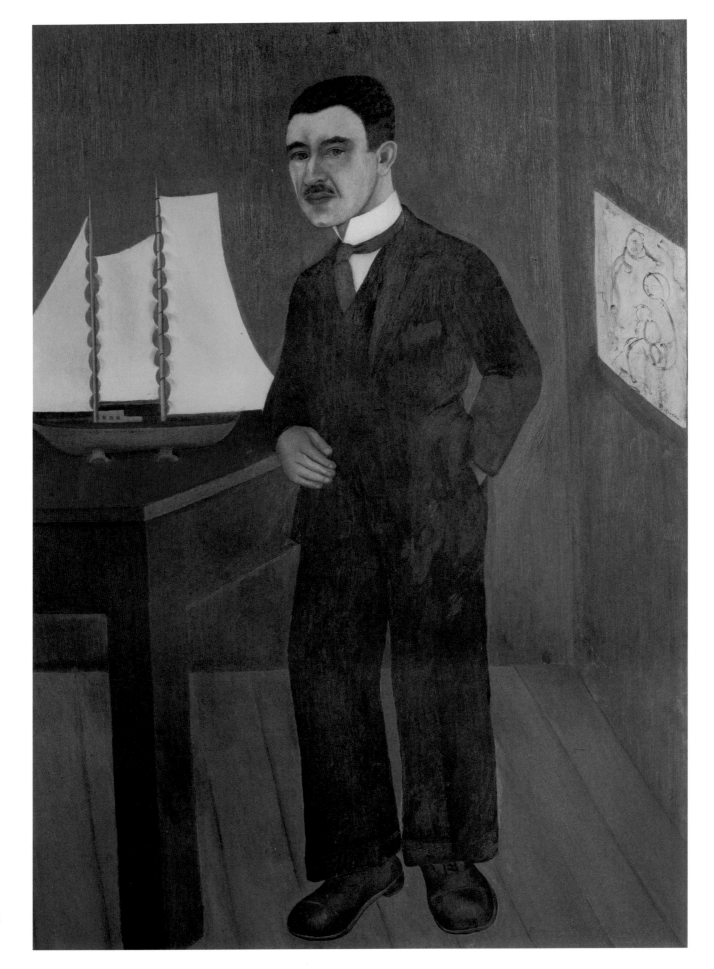

12.
Frida Kahlo
*Portrait of
Dr. Leo Eloesser*, 1931
Oil on Masonite,
33½ x 23¼ in.
(85.1 x 59.1 cm)
University of California
San Francisco (UCSF)
School of Medicine,
Dean's Office at Zuckerberg
San Francisco General
Hospital and Trauma Center

that lasted twenty-four years, until her death.[33] The son of German immigrants, Eloesser reminded Kahlo of her father. On January 1, 1931, she wrote her mother, "We went to eat at a German restaurant with Dr. Eloesser, he likes everything German style; he plays the violin, he sings, oh, he dances too! And he drinks beer, and he always discusses philosophy . . . (in some ways he resembles, like two drops of water, my father)."[34] Kahlo spent many happy hours singing and drinking with Eloesser, who bought her a guitar and taught her to belt out folk songs in Russian, English, and French, in addition to the Mexican *corridos* they loved to sing together.[35] Kahlo expressed her gratitude by painting a loving portrait of her friend and soul mate, *Portrait of Dr. Leo Eloesser* (1931). The portrait (fig. 12) includes the doctor's schooner inscribed "Los Tres Amigos" (The Three Friends), alluding to the strong friendship he shared with Kahlo and Rivera.

Kahlo's health improved exponentially in San Francisco thanks to Eloesser's solicitous care. Her letters reveal that he treated her free of charge, and that when she didn't keep her medical appointments, he showed up at her doorstep and made sure she came to see him the very next day.[36]

Kahlo and Rivera briefly returned to Mexico, then traveled to New York and Detroit (1931–1933). Building on the foundations she established in San Francisco, Kahlo accelerated her personal, political, and artistic growth. Through it all she kept Eloesser in the loop. From New York, she wrote to share her scathing criticism of "Gringolandia" (as she called the US): "I don't like the high society here at all and I feel indignation at all these 'moneybags' around here, since I've seen thousands of people in the most terrible poverty, without anything to eat or anywhere to sleep. . . . It's frightful to see the rich throwing parties day and night while thousands and thousands of people are dying of hunger."[37] *My Dress Hangs There* (1933; fig. 13) is a direct visual response to the 1929 stock market collapse and the social unrest of the Great Depression.[38] In this context, however, it is significant to observe that Kahlo's Tehuana dress hangs disembodied at the very center of the composition. Kahlo is absent, but her indigenous dress, a stand-in for and alter ego of the artist, becomes a reluctant witness to the ills and tragic predicament of US society. In San Francisco, Kahlo began to construct her identity by donning a Tehuana costume. By 1933, the dress had become an emblem of her identity, inseparable from her very being.

A year earlier in Detroit, Kahlo wrote Eloesser frequently and at great length. She despised Detroit and was feeling terrible, both physically and emotionally. Most important, she found out that she was pregnant. In her letters she confided in Eloesser and openly shared her desire and attempt to abort the fetus in May 1932; her failure to do so; her ambivalent feelings about having a child; and her emotional turmoil in the aftermath of her near-fatal miscarriage on July 4, 1932.[39] Shortly after she was released from the hospital, Kahlo made

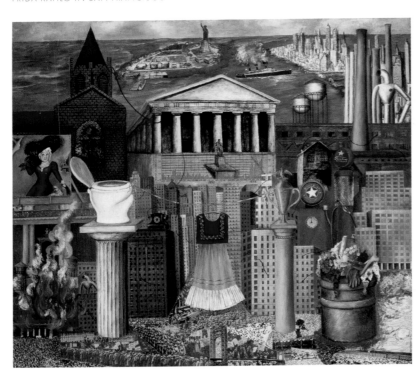

her first and only lithograph, titled *El Aborto* (*Frida and the Miscarriage*) (1932; pl. 17). The work shows Kahlo split in half, with complex images related to the loss of her fetus dominating her right side.[40] Her left half is darker and seems to be linked with the fertility of nature. From this side, Kahlo sprouts a third arm, like a Hindu deity. In her newly grown hand, she holds the painter's palette. In San Francisco, in April 1931, Kahlo had painted the same palette as Rivera's attribute, identifying him as the great artist and her husband; the lithograph visually proclaims Kahlo's rebirth as an artist in her own right. From this point on, she developed the radical and pathbreaking art for which she is known today. Until her dying day, she also continued to write her beloved Dr. Eloesser, knowing that he would always be there for her.

Soon after their departure from San Francisco, the Rivera-Kahlo relationship unraveled. By 1939, after much pain and marital woe, the marriage ended in divorce. In May 1940, following a failed attempt to assassinate the Russian political exile Leon Trotsky, Rivera was wanted by the police for questioning. Trotsky had been granted asylum in Mexico at Rivera's behest and initially resided in La Casa Azul. He had a brief and secretive affair with Kahlo and later, probably due to political disagreements, had a falling-out with Rivera.

Consequently, he moved from La Casa Azul into a house on Viena Street, Coyoacán (today the Museo Casa de León Trotsky). Rather than face police inquiry, Rivera was smuggled to San Francisco by plane with the aid of his lover at the time, actress Paulette Goddard. When Kahlo found out, she felt relieved that he was safe, but humiliated and devastated that he was with Goddard.[41] On August 20, 1940, Trotsky was stabbed with an ice pick by Stalinist agent Ramón Mercader and died of his wounds the next day. Rivera was still in San Francisco and Kahlo, who had casually encountered the assassin at a social gathering, was detained for questioning. The investigation was such an ordeal that Kahlo's already frail condition became worse. Rivera was worried about her safety and health. Kahlo did not allay his concerns but rather sent him a photograph in which she lay in bed with her eyes expressing pain and her body in traction. In consultation with Eloesser and through the doctor's concerted efforts, Rivera convinced Kahlo to fly to San Francisco for medical treatment. Her clinical records report that Eloesser ordered "absolute rest, very nutritious food, no alcoholic beverages, electrotherapy, calcium therapy" and that her condition improved rapidly. Eloesser also attended to Kahlo's emotional needs and acted as a go-between, ultimately negotiating the couple's second marriage.

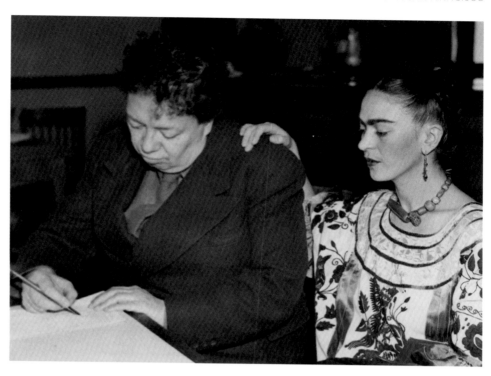

13.
Frida Kahlo
*My Dress Hangs
There*, 1933
Oil and collage on
Masonite, 18⅛ x 19½ in.
(46 x 49.5 cm)
Fundación FEMSA
Collection, Monterrey,
Mexico

14.
Frida Kahlo
Vista de New York, 1932
Pencil on paper,
10½ x 7⅞ in.
(27 x 20 cm)
Private collection,
courtesy of Galería Arvil,
Mexico City

15.
Frida Kahlo and Diego
Rivera applying for their
marriage certificate,
San Francisco City Hall,
1940. Photograph by
Paul Popper

On December 8, 1940—Rivera's 54th birthday—after thirteen months of divorce, Kahlo and Rivera remarried in San Francisco (see fig. 15). The second marriage certificate, unlike the first, lists Kahlo as a painter, not a housewife. Tellingly, in a mural that Rivera painted in San Francisco at that time, titled *Pan American Unity* (1940), Kahlo appears in all her indigenous glory, a Tehuana painter, with the palette and brushes in her hand. The terms of the marriage, drafted by Eloesser, accommodated Rivera's declaration that he was "incapable of monogamy" and Kahlo's refusal to share him with other women. It also addressed Kahlo's desire to be more independent. Consequently, they agreed to pursue a celibate union and to split all fiscal and domestic expenses.[42]

Kahlo painted her portrait for her confidant in a manner that reflected the nonsexual nature of her second marriage. *Self-Portrait Dedicated to Dr. Leo Eloesser* (1940; fig. 16) presents her wearing a Franciscan nun's brown habit, its dull color (contrasting with her typical Tehuana costumes) symbolizing mortification and humility. A crown of thorns surrounds her throat like a necklace, puncturing her skin and drawing blood. Kahlo's asceticism contrasts with the sensual flowers that adorn her hair, the hand-shaped earring that evokes the sense of touch, and the plants that grow behind her.[43] The caption reads: "I painted my portrait, in the year 1940, for Dr. Leo Eloesser, my physician and best friend. With all my love, Frida Kahlo." With this self-image, as noted by art historian Emmanuel Pernoud, Kahlo emulates a specific Mexican genre called *Monjas Coronadas* (Crowned Nuns).[44] She reveals her feelings to Eloesser and exposes her unhappiness in spite of her remarriage to Rivera. She remains a deeply divided being, split between sensual desire and a celibate predicament that perpetuates her unrequited love and longing for her husband.

16.
Frida Kahlo
*Self-Portrait Dedicated
to Dr. Leo Eloesser*, 1940
Oil on hardboard,
23⅜ x 15¾ in.
(59.5 x 40 cm)
Private collection

POSTHUMOUS TALES FROM SAN FRANCISCO

From 1940 on, Kahlo made a concerted effort to support herself as an artist. She applied for a Guggenheim Fellowship and tried to exhibit and sell her paintings. She was unsuccessful and, in a heart-rending letter professed: "The conclusion I've drawn is that all I've done is fail." Although she did show her work in group exhibitions and sold some of her canvases, mostly to friends, she had only two solo exhibitions during her lifetime. The first, a two-week exhibition at the Julien Levy Gallery on 57th Street, New York, presented twenty-five works (November 1–15, 1938). The second was organized by her friend, the photographer Lola Álvarez Bravo, in Mexico City's Galería de Arte Contemporáneo on April 13, 1953. A 1939 exhibition in a Paris gallery, titled *Mexique*, featured photographs and folk art alongside a selection of Kahlo's paintings.

Kahlo was not forgotten in Mexico even after her death in 1954, but she was known mainly as Rivera's wife. The Frida Kahlo Museum was opened in the Blue House in 1958, but only in recent decades has it become a popular site for visitors and adherents of "Fridamania." Kahlo's posthumous global acclaim began in San Francisco, with documentary filmmakers Karen and David Crommie of San Francisco completing the first international project devoted to Kahlo, in 1966. Titled *The Life and Death of Frida Kahlo* and based on numerous extensive interviews with Kahlo's close friends and associates conducted just a few years after the artist's death, the film remains an invaluable early source about the artist and her life.[45]

Two later projects are often credited with triggering the interest in Kahlo: the groundbreaking 1982 exhibition *Frida Kahlo and Tina Modotti* at the Whitechapel Art Gallery, London (which later traveled to additional international venues), and the publication of Hayden Herrera's monumental biography *Frida* in 1983. However, it was Latinx artists in San Francisco (at that time self-identifying as Chicano and Chicana) who reintroduced Frida Kahlo to the US art world as early as the 1970s. Their persistent appreciation of and engagement with Kahlo's art and life found potent expression in their own art, exhibited in San Francisco's Galería de la Raza. An homage to Kahlo, curated by Carmen Lomas Garza (with Kate Connell, Rupert García, María Pinedo, and Amalia Mesa-Bains serving as a curatorial committee), highlighted the artists' identification with Kahlo's Mexican heritage, ethnic pride, political resistance, and resilience. The exhibition opened on Día de los Muertos (Day of the Dead) in 1978, and continued Kahlo's San Francisco journey where she left off.

Around 1953, when she knew her days were numbered, Kahlo gave a trove of documents to Eloesser, who remained her most trusted friend. Among the hundreds of letters, drawings, and ephemera are Kahlo's San Francisco letters to family and friends. When Eloesser died in 1976, the collection was passed on to his heir, who sold it to the artist, curator, and art publisher Nelleke Nix and art consultant Marianne Huber in 1996. Later, Nix and Huber donated the materials to the National Museum of Women in the Arts in Washington, DC. Recently, Kahlo scholars like myself have mined this collection for new insights into the life and work of this great artist. From a relationship forged in San Francisco, Eloesser became one of the most supportive people in Kahlo's life and, as fate would have it, he has continued to support her legacy, even after their deaths.

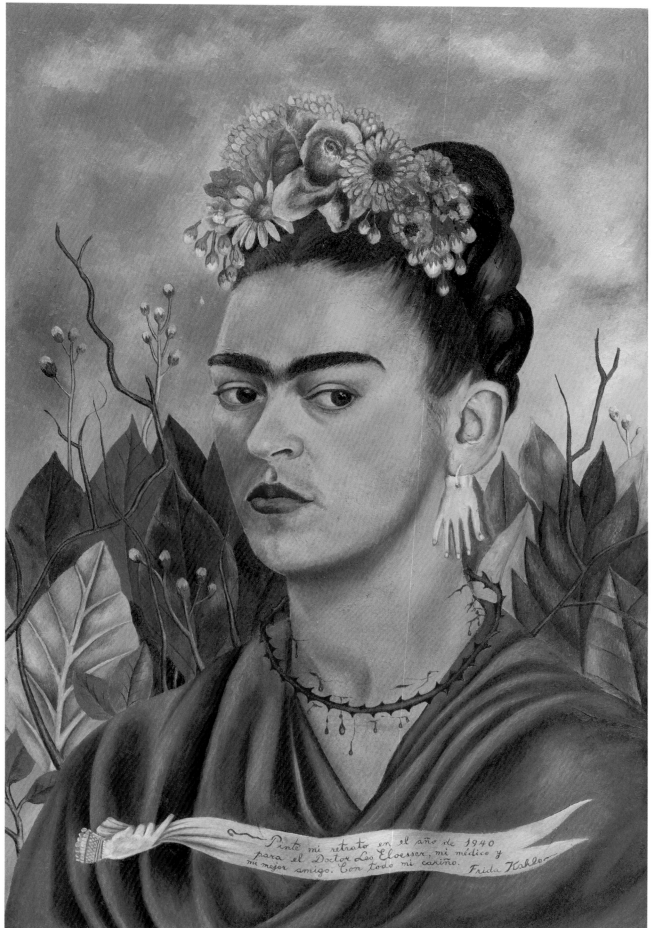

Pinté mi retrato en el año de 1940
para el Doctor Leo Eloesser, mi médico y
mi mejor amigo. Con todo mi cariño.
Frida Kahlo

[1] *The Queen of Montgomery Street* is the title of an unpublished play and story, written by John M. Weatherwax, in which Kahlo is the regal protagonist. The material is part of the John M. Weatherwax papers at the Archives of American Art, Smithsonian Institution, Washington, DC. See Ankori, *Critical Lives*, 79–84.

[2] Gannit Ankori, "The Poetics of Absence and Silence: Ishiuchi Miyako's Frida Kahlo Photographs," in *Frida by Ishiuchi* (Mexico City: RM, 2013), unpaginated.

[3] During his fourteen years in Paris, Diego Rivera lived with Angelina Beloff, who became his common-law wife and bore a son, who died in infancy. Back in Mexico, Rivera married Guadalupe Marín in 1922 and they had two daughters. They divorced in 1927 shortly after the birth of their second child. Rivera married Kahlo in August 1929. After her death, he married a fourth wife, Emma Hurtado.

[4] A copy of the marriage certificate, obtained from CENIDIAP archives, Mexico City, is in the author's private collection.

[5] Rivera was commissioned to paint the mural *Allegory of California* (1931) at the Stock Exchange (today's City Club of San Francisco). At the invitation of William Gerstle, president of the San Francisco Art Institute, Rivera also painted *The Making of a Fresco Showing the Building of a City* (1931) at the school. He later took on additional private commissions.

[6] Kahlo wrote her family and friends very frequently during her stay in San Francisco. Most letters include complaints that she did not receive replies as quickly as she had hoped. She also writes extensively about her health and inquires about the health of her family members. Money is another issue that comes up often. The letters are quoted extensively in Gannit Ankori, *Critical Lives: Frida Kahlo*. London: Reaktion Books Ltd., 2013, repr. 2018, accessed in 2011 and 2012 from the Nelleke Nix and Marianne Huber Collection, National Museum of Women in the Arts Archive, Library and Research Center in Washington, DC (heretofore NMWA archives). In 2018, English translations of select letters were published: Frida Kahlo, *You Are Always with Me: Letters to Mama: 1923–1932*, translated and edited by Héctor Jaimes (London: Virago, 2018); see letters from San Francisco, 37–121. Although the author has used her own translations, she has added references to Jaimes whenever possible, to help orient the reader. This volume is the latest addition to anthologies of Kahlo's correspondence, edited by Raquel Tibol, Marta Zamora, Salomon Grimberg, and Cristina Secci.

[7] Jaimes, 50.

[8] Relevant letters are quoted in Jaimes: ethnic neighborhoods, 57–58; Fairfax, 55; Stanford, 57; first plane ride, 63; Chinese New Year, 95–96; Chinese ambassador, 57; Legion of Honor lecture, 66; Chaplin film, 83; puppet show, 68; drunk man, 74–75; "walkathon," 79.

[9] For more details on the "walkathon"—a development of the dance marathon—see Carol J. Martin, *Dance Marathons: Performing American Culture in the 1920s and 1930s* (Jackson: University Press of Mississippi, 1994). Also see Horace McCoy, *They Shoot Horses, Don't They?* (1935) and the eponymous film directed by Sydney Pollack featuring Jane Fonda (1969).

[10] Relevant letters quoted in Jaimes: Chinese and Mexicans, 96; Chinese seamstress, 104; Chinatown, 50.

[11] Jaimes, 55. Elsewhere she reports that she attended a dinner party and that "all the gringos liked me. . . . I went with my embroidered shirt and rebozo shawl and I was the centerpiece, because here they are too dull" (Jaimes, 77). This sentence appeared in Gannit Ankori, *Critical Lives: Frida Kahlo*. London: Reaktion Books Ltd., 2013, repr. 2018.

[12] Excellent studies on Kahlo and photography have been published over the years, as for example: Salomon Grimberg, *Lola Álvarez Bravo: The Frida Kahlo Photographs* (Dallas: Meadows Museum, 1991); Elena Poniatowska and Carla Stellweg, *Frida Kahlo: The Camera Seduced* (San Francisco: Chronicle Books, 1992); Margaret Hooks, *Frida Kahlo: Portrait of an Icon* (New York: Throckmorton Fine Arts, 2002); Salomon Grimberg, *I Will Never Forget You* (Munich: Schirmer/Mosel, 2004); Elizabeth Carpenter, "Photographic Memory: A Life (and Death) in Pictures," in *Frida Kahlo* (Minneapolis: Walker Art Gallery, 2007), 36–55; Pablo Ortiz Monasterio, ed., *Frida Kahlo: Her Photos* (Mexico: Editorial RM, 2010); and *Mirror Mirror . . . Portraits of Frida Kahlo* (New York: Throckmorton Fine Arts, 2015). On the close relationship between photographs of Kahlo and her self-portraiture, also see Gannit Ankori, "Posing, Composing, Exposing," in Claire Wilcox and Circe Henestrosa, eds., *Frida Kahlo: Making Her Self Up* (London: Victoria and Albert Museum, 2018), 130–159.

[13] Among the photographs found at La Casa Azul, several images show Kahlo's father and mother posing in a variety of costumes. Her mother, for example, posed as "Adelita," and her father posed nude, as an intellectual, and as a frumpy hobo.

[14] Edward Weston, *The Daybooks of Edward Weston*, vol. 2 (New York: An Aperture Book, 1973), 198–199.

[15] Jaimes, 67–68.

[16] Primary sources regarding Kahlo's relationship with the Wights and Lady Hastings may be surmised from her letters to them and from archival sources, specifically the NMWA archives, private archives in London, and the Clifford Wight Papers in Syracuse University Archives.

[17] See Linda Gordon, *Dorothea Lange: A Life beyond Limits* (London and New York: Norton, 2009), 96; Karen Chernick, "Frida Kahlo's Friendship with Dorothea Lange was Good for Her Health," in *Hyperallergic*, January 16, 2019 (hyperallergic.com/479868/frida-kahlos-friendship-with-dorothea-lange-was-good-for-her-health).

[18] On Christmas Day, Kahlo wrote her mother: "I am painting a lot, almost every day; it's the only way time goes by and I am able to put my mind off things, and not be too sad" (Jaimes, 70).

[19] The copyright owners of one of these photographs noted its publication date "1/22/1931" and the original caption. An unfinished painting titled *Portrait of a Lady in White* is dated by scholars as ca. 1929. Based on drawings and photographs, this may be a portrait of Lady Cristina Hastings, with whom Kahlo developed an intense relationship, even after both women left San Francisco.

[20] Two small and faded photographs from the Vicente Wolf Photograph Collection show Kahlo sitting with a woman who appears to be Frederick, in poses that reflect a close, perhaps intimate, relationship.

[21] Jaimes, 95.

[22] Jaimes, 135.

[23] There is one photograph of the two women together. The rumor that they had sexual relations has never been substantiated.

[24] This text is repurposed from Gannit Ankori, *Critical Lives: Frida Kahlo*. London: Reaktion Books Ltd., 2013, repr. 2018.

[25] Ibid.

[26] Ibid.

[27] This text is repurposed from Gannit Ankori, *Critical Lives: Frida Kahlo*. London: Reaktion Books Ltd., 2013, repr. 2018.

[28] All quotes from the Weatherwax papers, Archives of American Art (see note 1).

[29] Weatherwax provides a fictional quote that seems to be at odds with Rivera's derogatory quote cited by a contemporaneous newspaper.

[30] This text is repurposed from Gannit Ankori, *Critical Lives: Frida Kahlo*. London: Reaktion Books Ltd., 2013, repr. 2018.

[31] Articles that patronized and belittled Kahlo during her lifetime abound. A 1933 *Detroit Herald* headline reads: "Wife of the Master Mural Painter Gleefully Dabbles in Works of Art" and *Time* magazine called her "black-browed little Frida" in 1938. See Gannit Ankori, *Critical Lives: Frida Kahlo*. London: Reaktion Books Ltd., 2013, repr. 2018.

[32] See notes 6 and 14.

[33] This text is repurposed from Gannit Ankori, *Critical Lives: Frida Kahlo*. London: Reaktion Books Ltd., 2013, repr. 2018.

[34] Jaimes, 74.

[35] Jaimes, 77.

[36] Tibol, ed. *Frida by Frida*, 104–105.

[37] Tibol, ed. *Frida by Frida*, 105.

[38] See Ankori, *Critical Lives*, 103–105, for a detailed analysis of how the painting lucidly conveys Kahlo's unequivocal political and social positions at the time.

[39] Letters quoted in Ankori, *Critical Lives*, 86–98, 211–213.

[40] Kahlo composed and printed the lithograph on August 11, 1932 (as witnessed and journaled by the artist Lucienne Bloch who was with her). For a full discussion of the lithograph, see "Birth of the Artist" in Gannit Ankori, "Frida Kahlo: The Fabric of Her Art," Emma Dexter and Tanya Barson, eds., *Frida Kahlo* (London: Tate Publishing, 2005), 36–38, 44–45.

[41] Kahlo letter to Rivera in 1940 in Ankori, *Critical Lives*, 116–123, and notes.

[42] Ankori, *Critical Lives*, 119–120.

[43] Circe Henestrosa has convincingly argued that the hand-shaped earring that Kahlo painted in this self-portrait is different from the earrings seen in photographs and drawings, which were a gift from Picasso. The earring in this painting has been found in La Casa Azul. The author thanks Henestrosa for sharing a photograph of it as well as her knowledge.

[44] See "The Ascetic Self" in Gannit Ankori, *Imaging Her Selves: Frida Kahlo's Poetics of Identity and Fragmentation* (Westport and London: Greenwood Press, 2002), 201–222.

[45] Karen and David Crommie, *The Life and Death of Frida Kahlo*, film, 1966.

Gallery

CONSTRUCTING HER IDENTITY

The exhibition at the Fine Arts Museums of San Francisco is guest curated
by Circe Henestrosa with Gannit Ankori as advising curator, and with
Hillary C. Olcott serving as the coordinating curator.

AN INTRODUCTION TO THE GALLERY

"MADAME RIVERA SEEMS HERSELF A PRODUCT OF HER ART, AND, LIKE ALL HER WORK,
ONE THAT IS INSTINCTIVELY AND CALCULATEDLY WELL COMPOSED."
—Bertram D. Wolfe, *Vogue*, 1938

Frida Kahlo is remembered and admired as much for her unique personal style as for her powerful paintings. She took care to modify her garments and assemble her ensembles, coiffing her braided updos and carefully selecting her jewelry and other accessories. But making herself up was about much more than her looks: Kahlo used her appearance to explore and express her feelings, to celebrate her ethnic and national heritage, and to communicate her deeply held principles. In her paintings and drawings, clothing and hairstyle were part of the visual vocabulary that the artist used to represent different versions of herself. Kahlo's style was her personal manifesto—an expression of her life, her experiences, her passions, and her beliefs. It was a reflection and realization of her consciously self-constructed identity.

As discussed in this volume, Kahlo's time in San Francisco was deeply impactful. The city shaped her developing character and launched her artistic path. But Kahlo's self-construction first began with her family during her formative years. The artist was proud of her multiethnic heritage and expressed it in her dress and her art, honoring both her mestiza Mexican mother and her German father. The time that Kahlo spent with her father in his photography studio taught her how to pose for portraits and create compositions. Her experience growing up during the Mexican Revolution (1910–1920) instilled in her a strong sense of social justice and national pride. One of the most pivotal moments of Kahlo's life occurred on September 17, 1925, when, at the age of eighteen, the bus she was riding home in was struck by a tram. Kahlo was severely injured and was bedbound for months. It was during this time that she began to paint. Using a folding easel and a mirror set into the canopy of her four-poster bed, she began to develop the self-portraiture for which she later became internationally recognized.

As detailed in this publication, the accident also left Kahlo with permanent disabilities and chronic pain. Over the course of her life, she underwent dozens of surgeries and other medical procedures to attempt to alleviate the acute problems that plagued her right leg, spinal column, and reproductive system. At times, she needed to wear corsets and other apparatuses, which she decorated and transformed into works of art. Conversely, she composed her paintings to examine her experiences of illness, disability, loneliness, and pain. Her art was a means to express that physical and emotional suffering while also demonstrating her resilience and capacity to create beauty, joy, and profound meaning.

The photographs, drawings, ensembles, and paintings presented in this gallery offer a rare opportunity to examine Frida Kahlo's diverse modes of creativity. These works of art demonstrate the evolution of her self-creation, from a child pictured by her father and later herself, to a teenager who dressed unconventionally to express her individuality, to a young woman who wore Mexican dresses as a reflection of her ethnicity, and to her iconic take on the style of La Tehuana. The works also reveal the multifaceted layers of Kahlo's identity: her explorations of gender, her experiences with disability, her ethnicity, and her communist worldview. It is interesting to consider, and striking to see, the role that San Francisco played in the artist's development and the factors that informed the creation of her distinctive identity and her bold and uncompromising art.

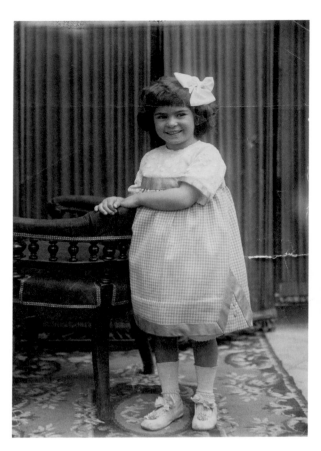

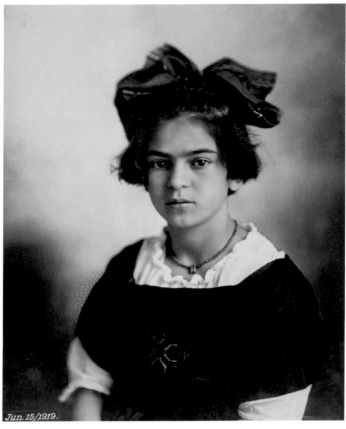

1.
Guillermo Kahlo
Frida Kahlo age 4, 1911
Gelatin silver print,
6¾ x 4¾ in. (17.1 x 12 cm)
Museo Frida Kahlo, Mexico City

2.
Guillermo Kahlo
Frida Kahlo, June 15, 1919
Gelatin silver print,
9⅝ x 7½ in. (24.4 x 19 cm)
Museo Frida Kahlo, Mexico City

3.
Guillermo Kahlo
Frida Kahlo, ca. 1926
Gelatin silver print,
6¾ x 4¾ in. (17.2 x 12.2 cm)
Museo Frida Kahlo, Mexico City

4.
Frida Kahlo
Untitled (Triple Self Portrait), 1931
Pencil on paper,
21⅝ x 18¾ in.
(54.9 x 47.5 cm)
Private collection

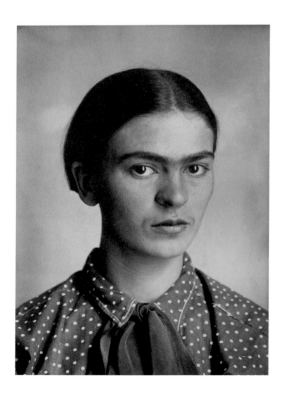

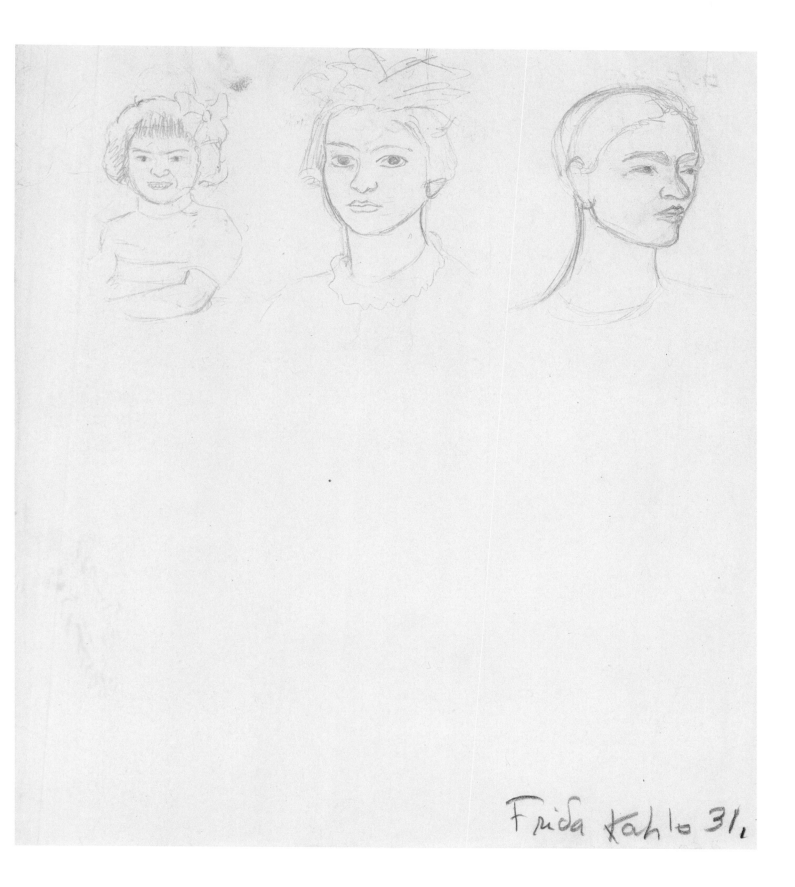

Frida Kahlo 31,

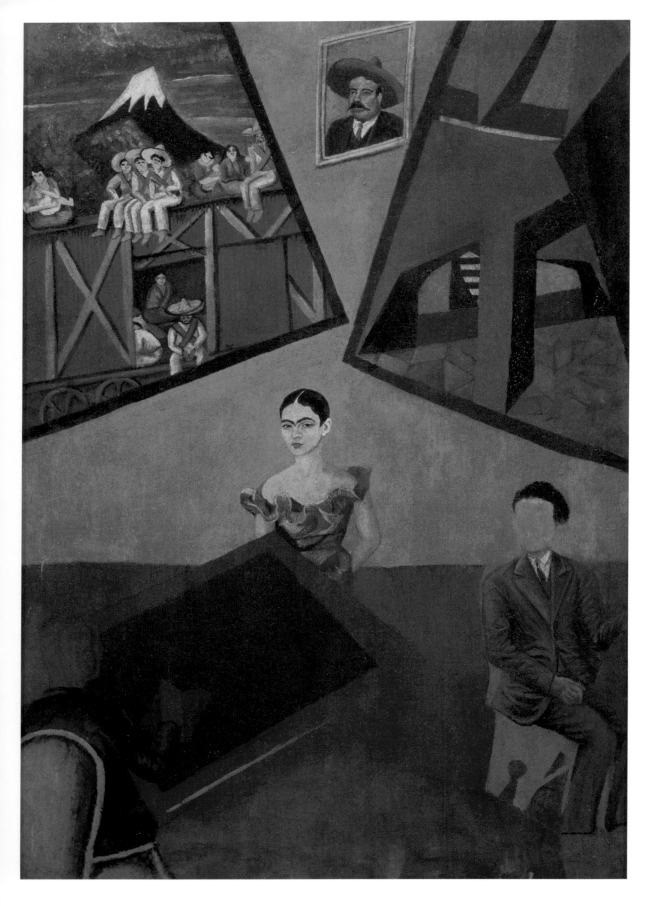

5.
Frida Kahlo
Pancho Villa and Adelita, ca. 1927
Oil on canvas,
25⅝ x 17¾ in.
(65 x 45 cm)
Government of the State of Tlaxcala, Instituto Tlaxcalteca de Cultura, Museo de Arte de Tlaxcala, Mexico

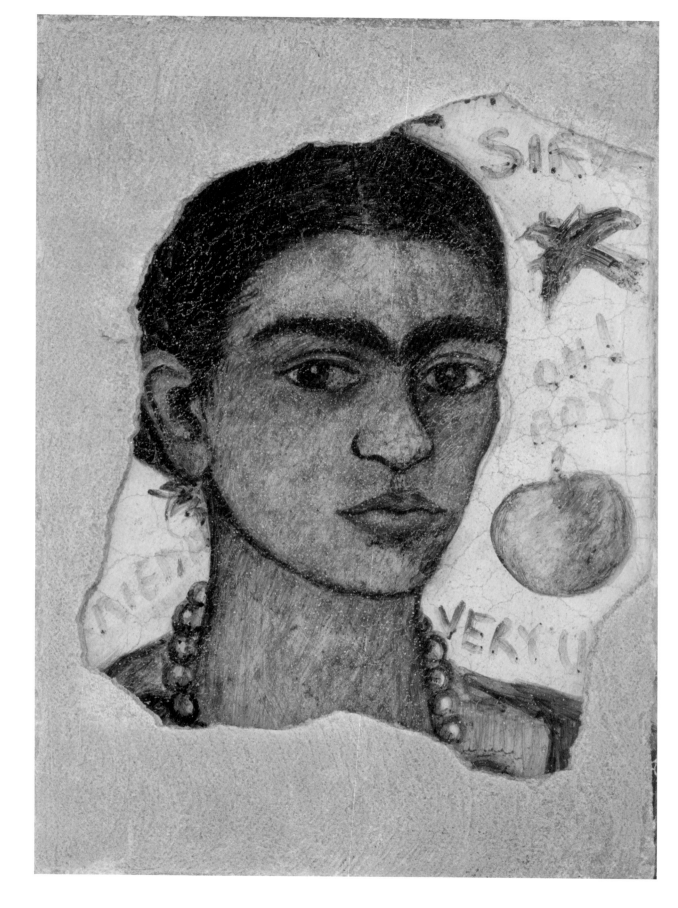

6.
Frida Kahlo
Self-Portrait
"Very Ugly," 1933
Fresco fragment,
10⅝ x 8¾ in.
(27 x 22.2 cm)
Private collection

7.
Frida Kahlo
Self-Portrait Drawing,
ca. 1938
Pencil and colored
pencil on tracing paper,
11 x 8½ in.
(27.9 x 21.6 cm)
Private collection

8.
Julien Levy
Frida Kahlo, ca. 1938
Gelatin silver print,
1⅜ x ⅞ in. (3.4 x 2.2 cm)
Philadelphia Museum of
Art, 125th Anniversary
Acquisition, The Lynne
and Harold Honickman
Gift of the Julien Levy
Collection, 2001,
2001-62-635

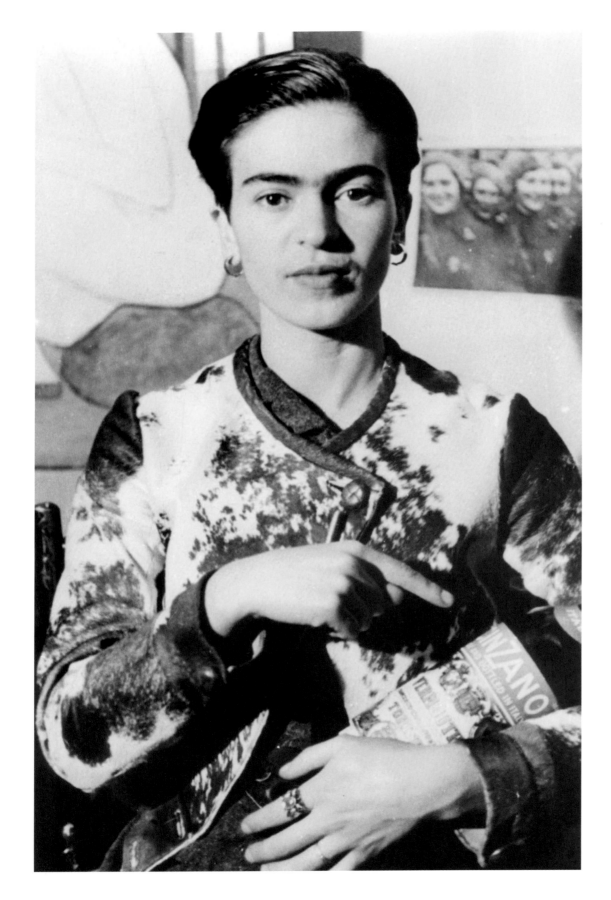

9.
Lucienne Bloch
Frida Kahlo with cropped
hair, wearing a mottled
leather bolero and cradling
a bottle of Cinzano, 1935
Gelatin silver print,
8⅝ x 6⅝ in. (22 x 17 cm)
The Hecksher Family
Collection

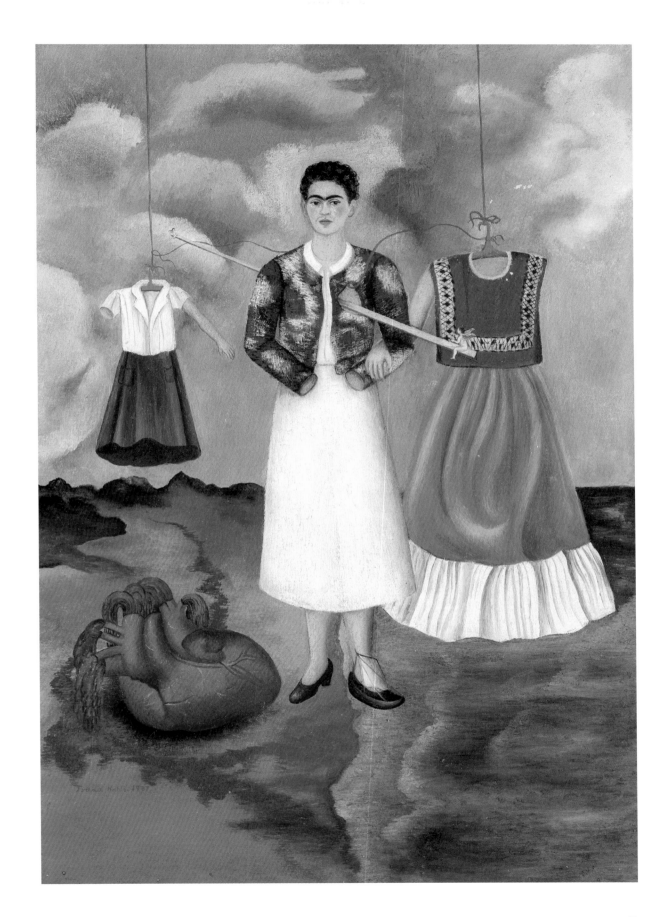

10.
Frida Kahlo
Memory or
The Heart, 1937
Oil on metal,
15 ¾ x 11 ⅛ in.
(40 x 28 cm)
Private collection

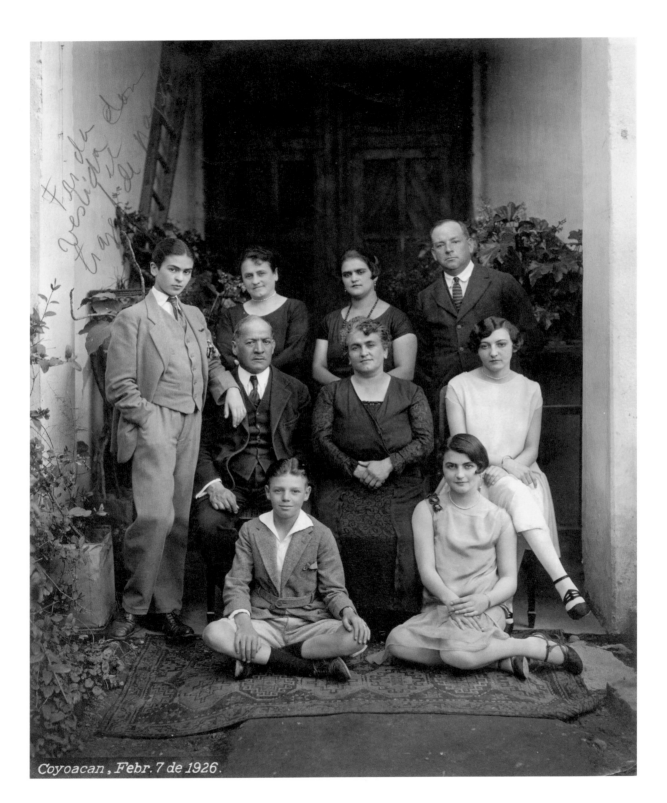

Coyoacan, Febr. 7 de 1926.

11.
Guillermo Kahlo
Kahlo Family Portrait,
February 7, 1926
Gelatin silver print,
9¾ x 7¾ in.
(24.6 x 19.8 cm)
The Vicente Wolf Collection

12.
Frida Kahlo
*Self-Portrait with
Cropped Hair*, 1940
Oil on canvas,
15¾ x 11 in. (40 x 27.9 cm)
The Museum of Modern
Art, New York, Gift of Edgar
Kaufmann, Jr.
1943, 3.1943

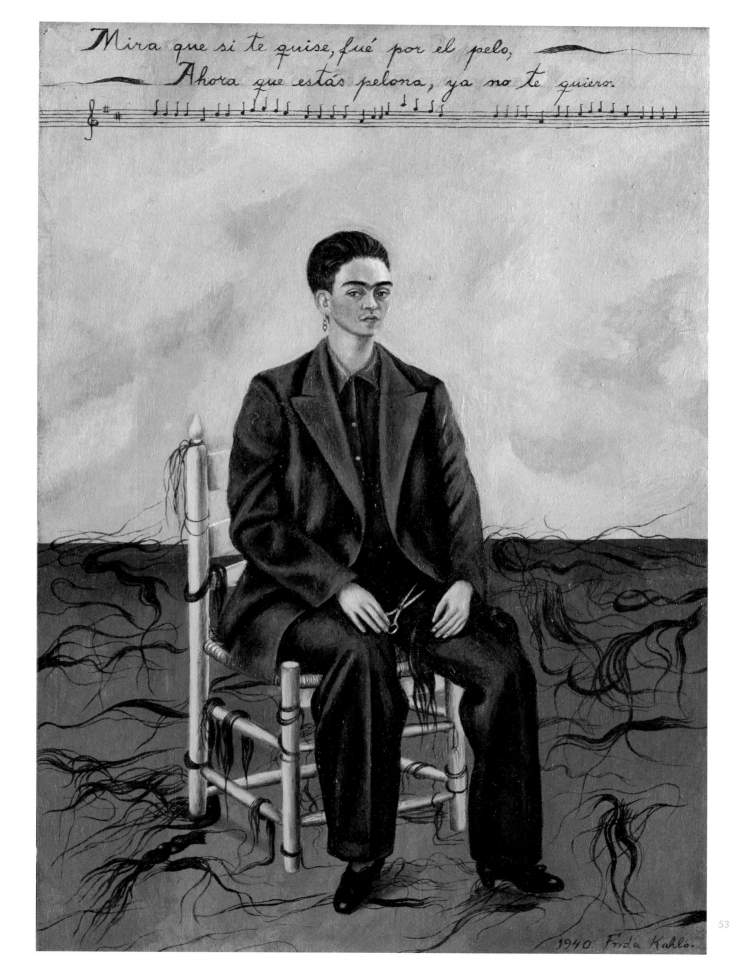

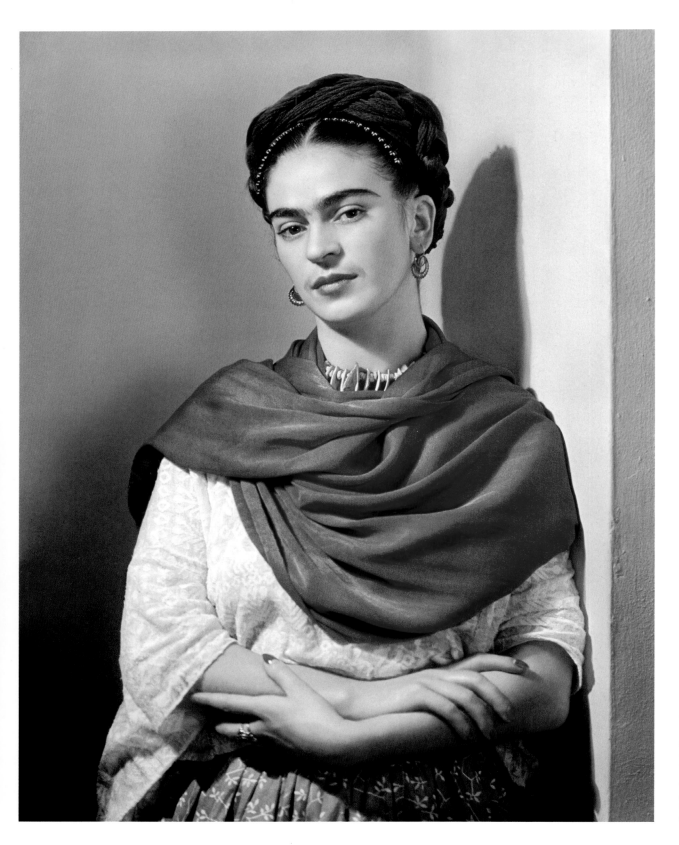

13.
Nickolas Muray
*Frida with Magenta
Rebozo, New York
City*, 1939
Inkjet print,
18½ x 11½ in.
(47 x 29 cm)
The Hecksher Family
Collection

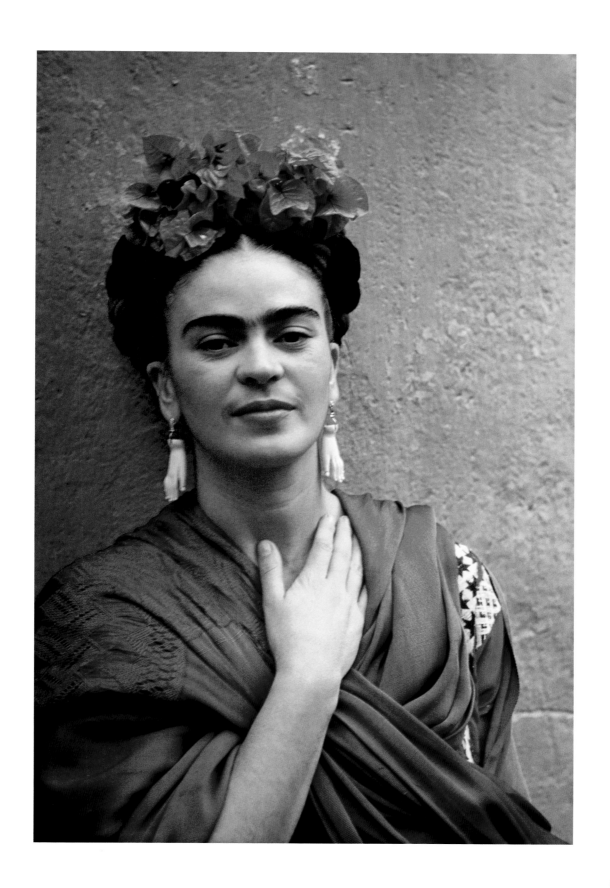

14.
Nickolas Muray
*Frida with Picasso
Earrings, Coyoacán*,
1939
Inkjet print, 13¾ x 9 in.
(34.8 x 23.2 cm)
The Hecksher Family
Collection

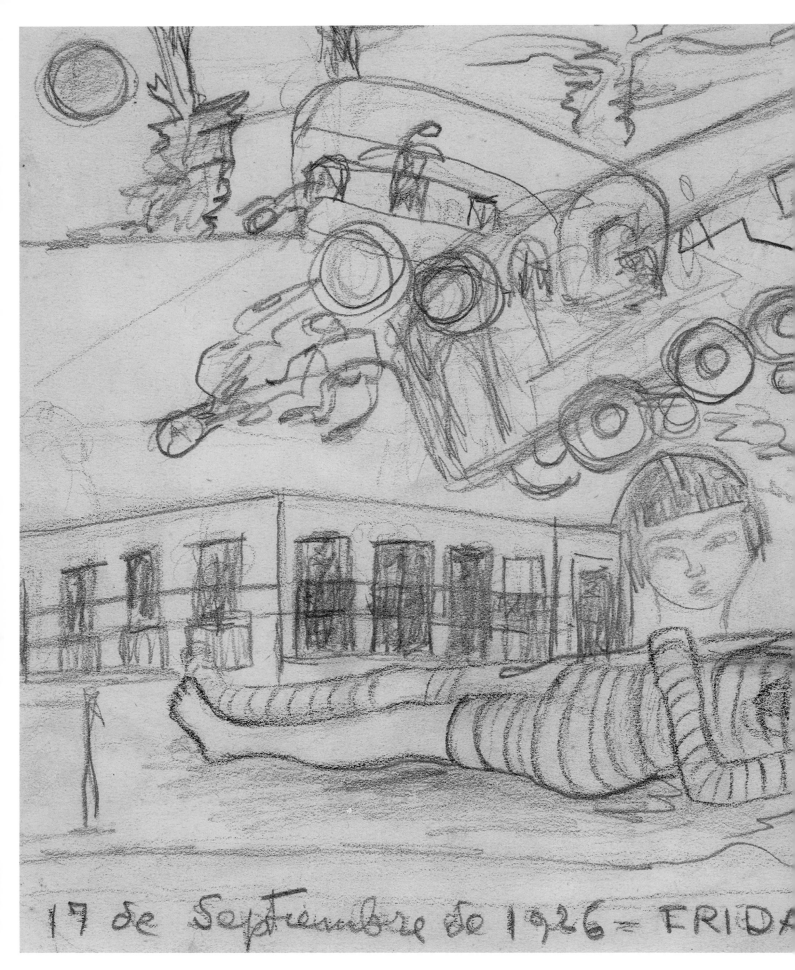

17 de Septiembre de 1926 = FRIDA

15.
Frida Kahlo
The Accident,
September 17, 1926,
1926
Pencil on paper,
7 ¾ x 10 ⅝ in.
(20 x 27 cm)
Colección Juan Rafael
Coronel Rivera

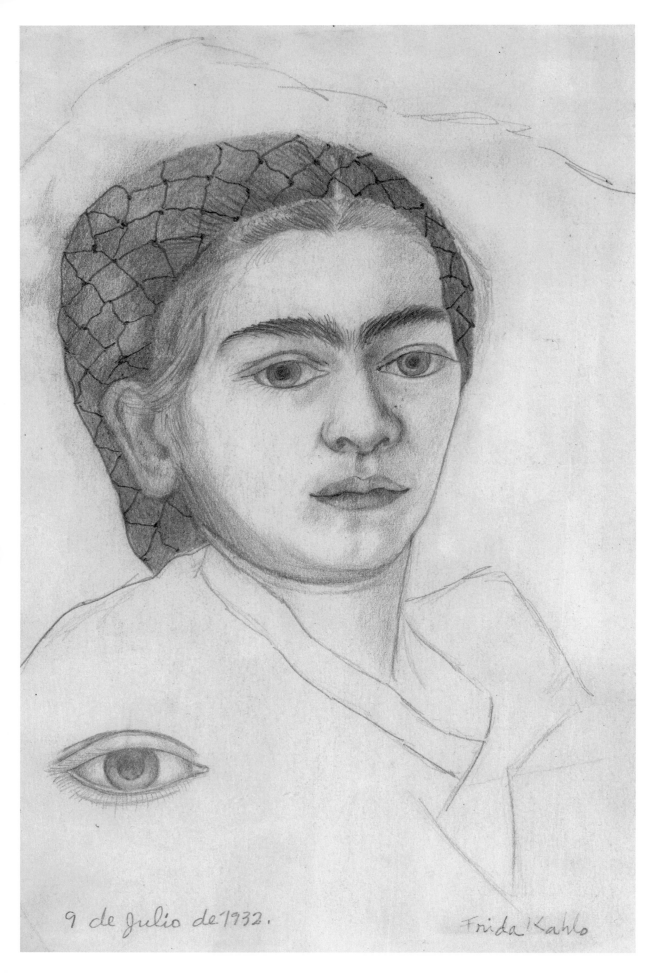

9 de Julio de 1932.

Frida Kahlo

16.
Frida Kahlo
*Self-Portrait,
July 9, 1932*, 1932
Pencil on paper,
8½ x 5½ in. (21.5 x 14 cm)
Colección Juan Rafael
Coronel Rivera

17.
Frida Kahlo
El Aborto (*Frida and the
Miscarriage*), 1932
Lithograph, 8¾ x 5½ in.
(22.2 x 14.2 cm)
Fine Arts Museums of
San Francisco, Museum
purchase, Dr. R. Earl
Robinson Estate and
Achenbach Foundation for
Graphic Arts Endowment
Fund, 1996.38

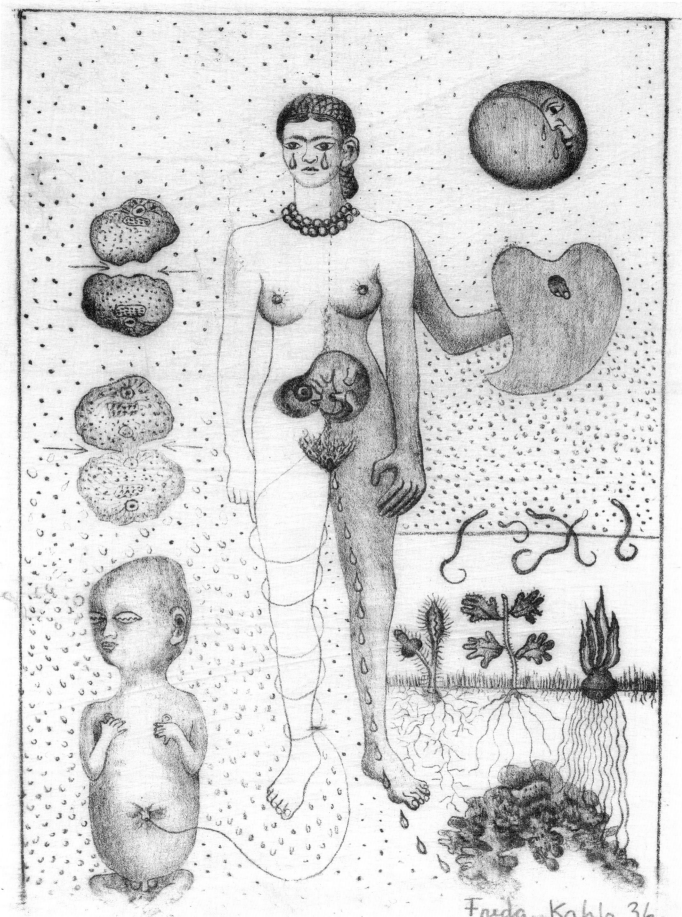

Freda Kahlo 36.

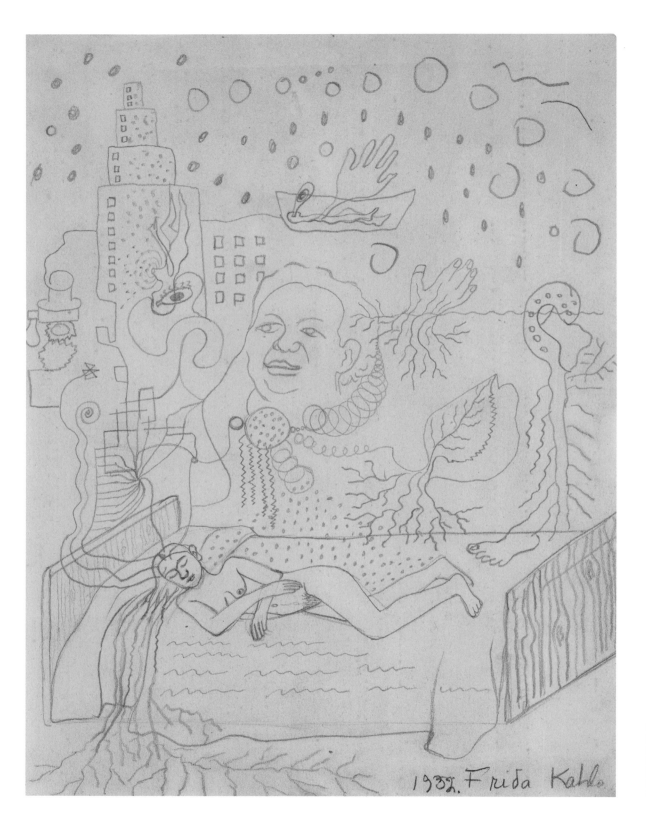

1932. Frida Kahlo

18.
Frida Kahlo
The Dream, 1932
Pencil on paper,
10⅝ x 7⅞ in. (27 x 20 cm)
Colección Juan Rafael
Coronel Rivera

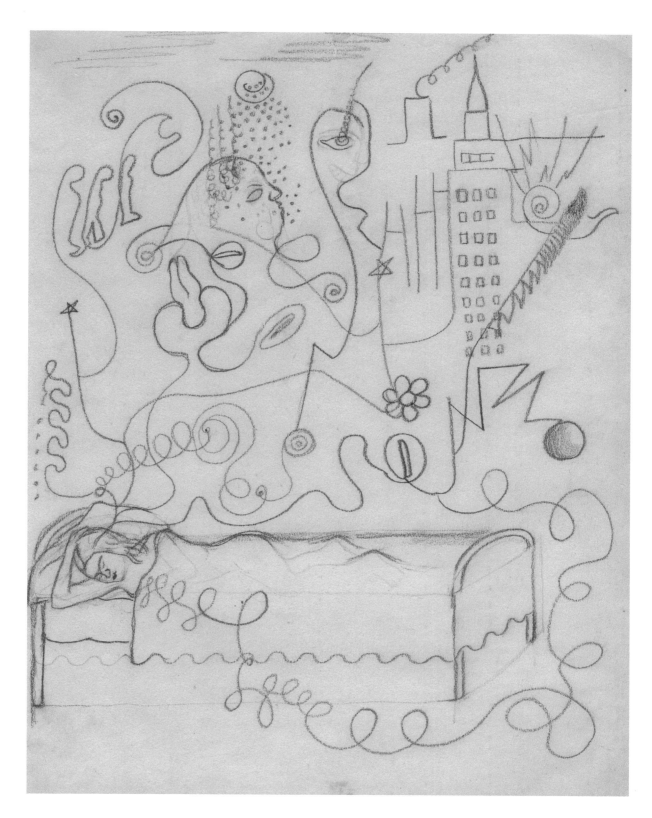

19.
Frida Kahlo
Sleeping Self-Portrait,
1932
Pencil on paper,
10⅝ x 8¼ in.
(27 x 21 cm)
Museo Frida Kahlo,
Mexico City

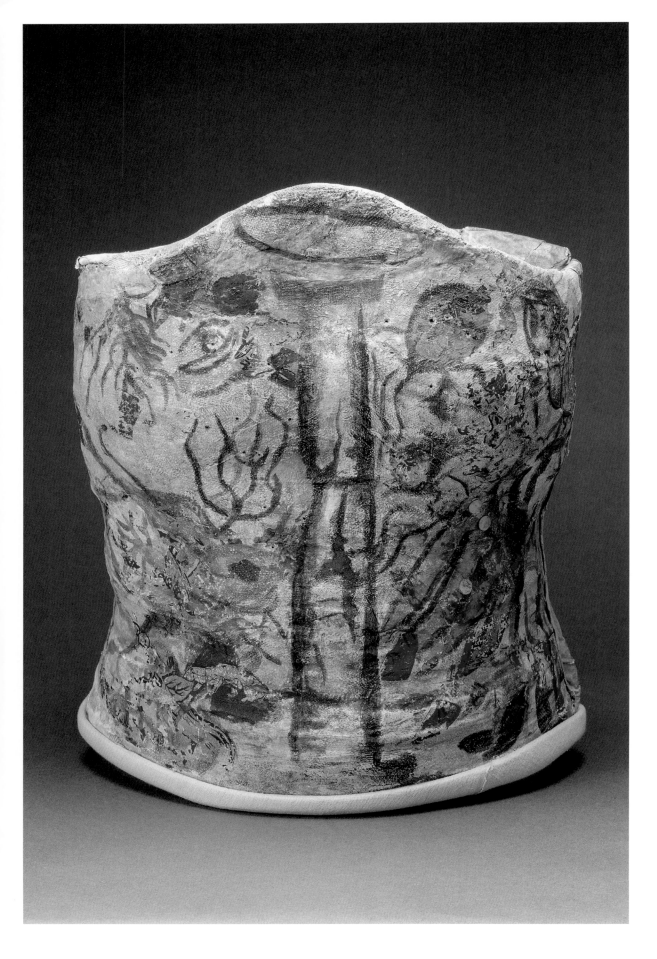

20.
Frida Kahlo
Plaster corset, painted
and decorated, ca. 1944
Museo Frida Kahlo,
Mexico City

21.
Frida Kahlo
The Broken Column, 1944
Oil on canvas, 15¾ x 12 in.
(40 x 30.5 cm)
Museo Dolores Olmedo
Patiño, Mexico City

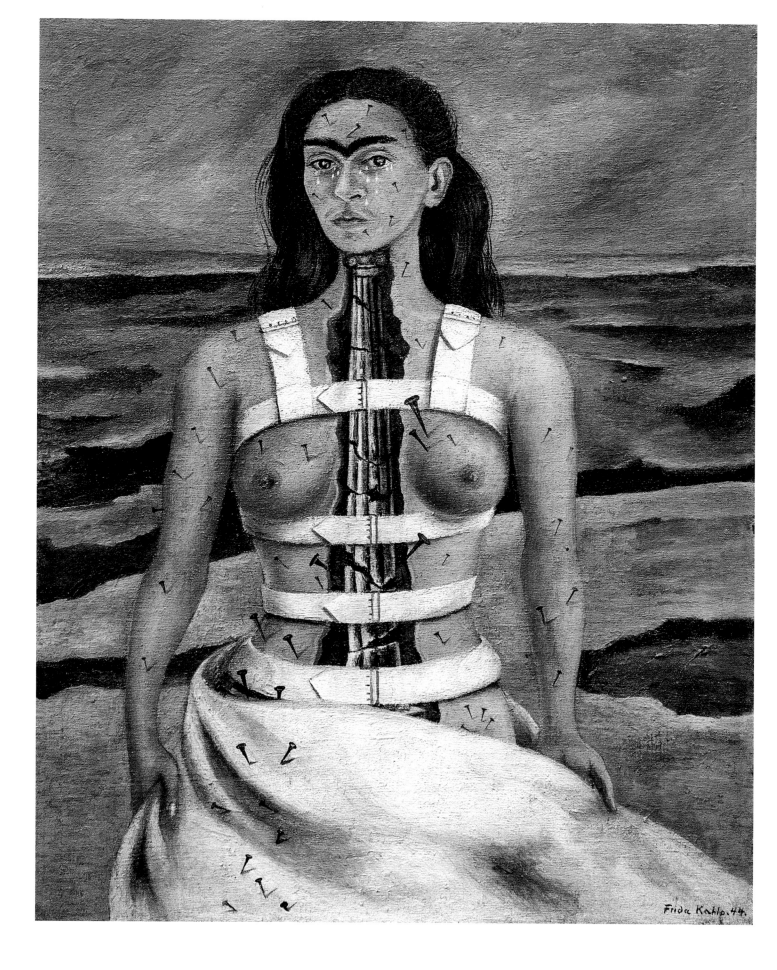

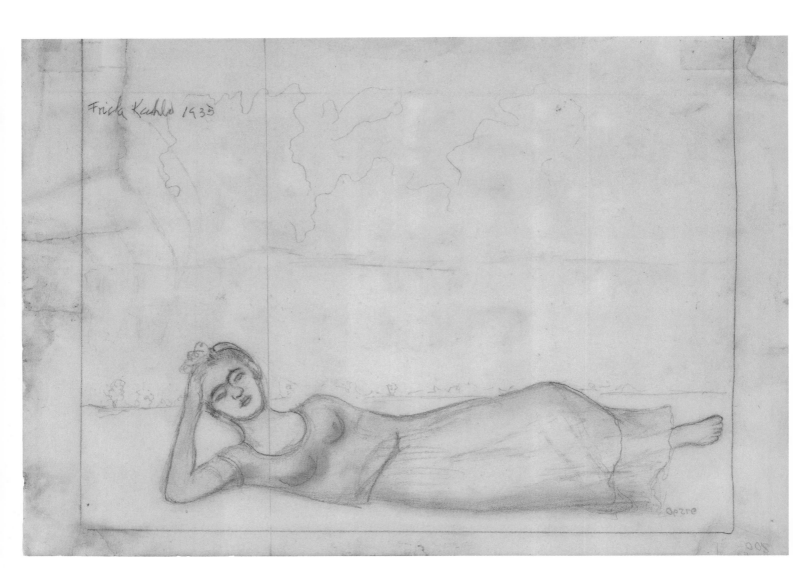

22.
Frida Kahlo
Self-Portrait Reclining, 1935
Pencil on paper,
8⅛ x 11¾ in.
(20.7 x 29.7 cm)
Colección Juan Rafael
Coronel Rivera

23.
Frida Kahlo
The Suicide of Dorothy Hale, 1939
Oil on Masonite with
painted frame,
25½ x 19½ in.
(64.8 x 49.5 cm)
Phoenix Art Museum,
Gift of an anonymous
donor, 1960.20

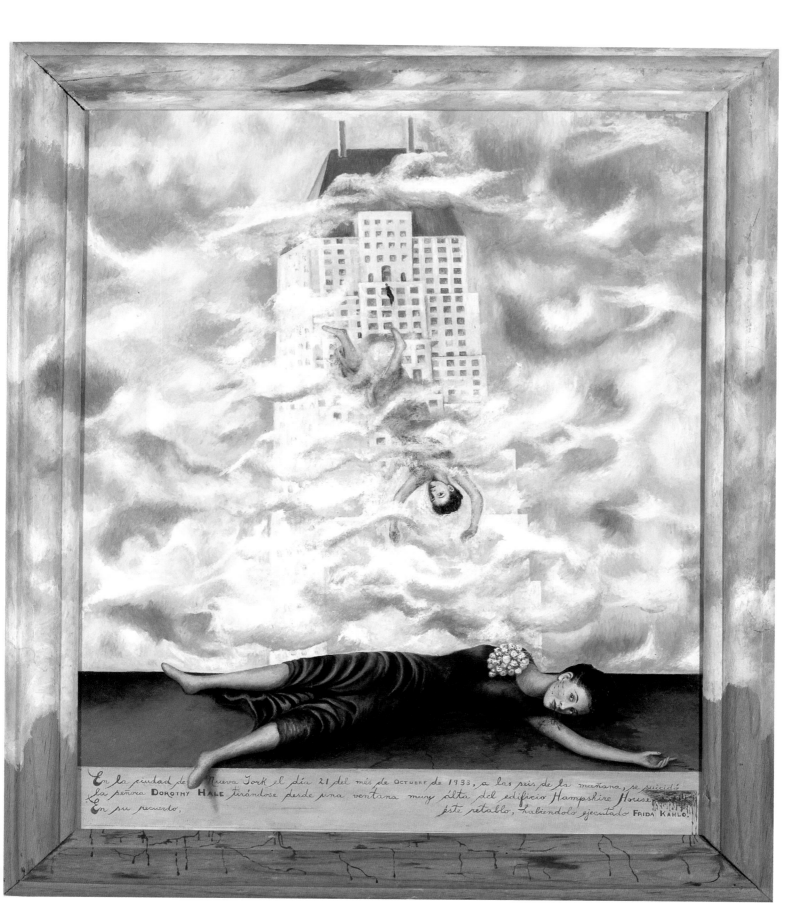

En la ciudad de Nueva York el día 21 del mes de Octubre de 1933, a las seis de la mañana, se suicidó la señora DOROTHY HALE tirándose desde una ventana muy alta del edificio Hampshire House. En su recuerdo, este retablo, habiéndolo ejecutado FRIDA KAHLO.

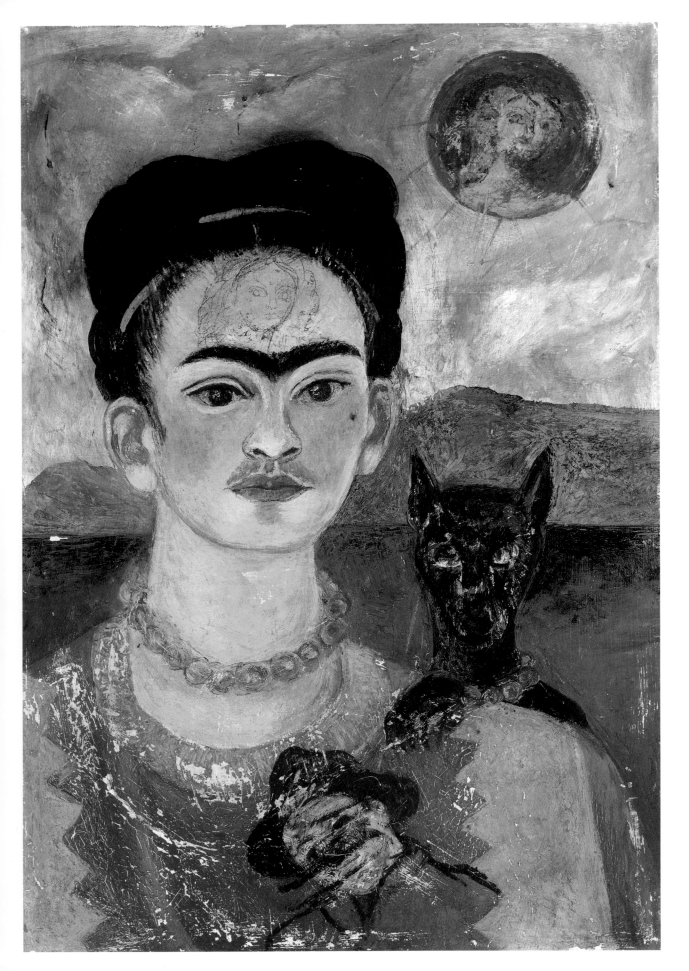

24.
Frida Kahlo
Self-Portrait with Diego on My Breast and Maria on My Brow, 1954
Oil on Masonite,
24 x 16 in. (61 x 41 cm)
Private collection

25.
Frida Kahlo
Untitled, n.d.
Charcoal on paper,
5 3/8 x 4 1/4 in.
(13.8 x 10.8 cm)
Museo Frida Kahlo,
Mexico City

26.
Frida Kahlo
Diary entry, ca. 1944
Museo Frida Kahlo,
Mexico City

27.
Frida Kahlo
Diary entry, n.d.
Museo Frida Kahlo,
Mexico City

28.
Frida Kahlo
*Sketch of the Ceiling
of My Home*, 1944
Pencil on paper,
9½ x 14 in.
(24.1 x 35.6 cm)
Museo Frida Kahlo,
Mexico City

29.
Frida Kahlo
*Girl from Tehuacán.
Lucha Maria*, 1942
Oil on Masonite,
21½ x 17 in.
(54.5 x 43.3 cm)
Pérez Simón Collection,
Mexico City

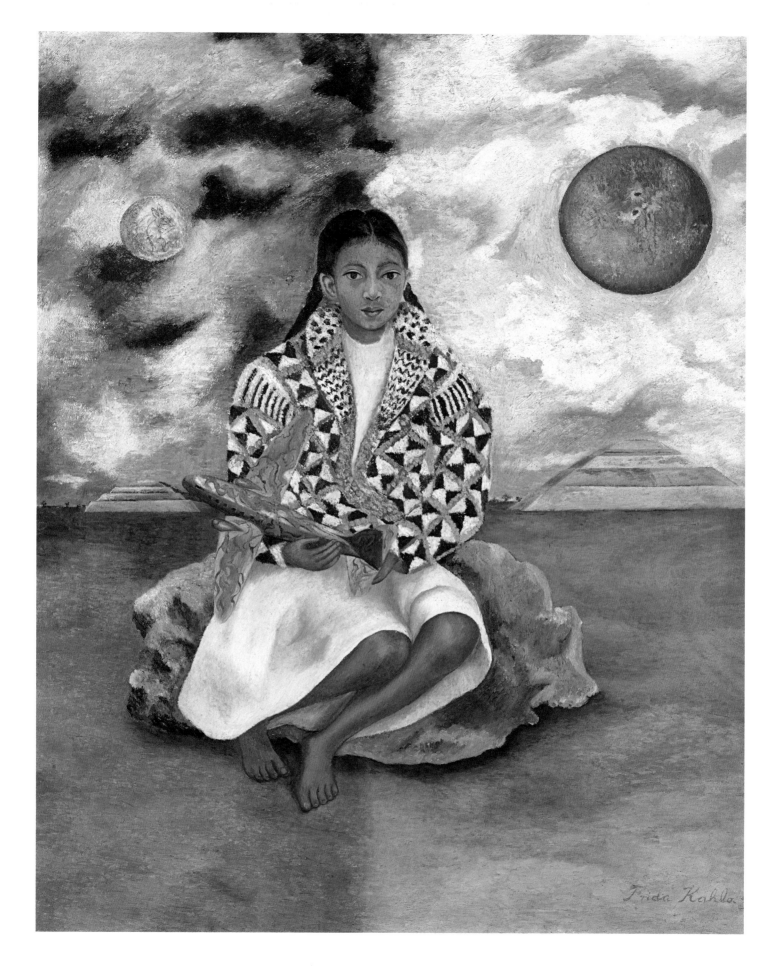

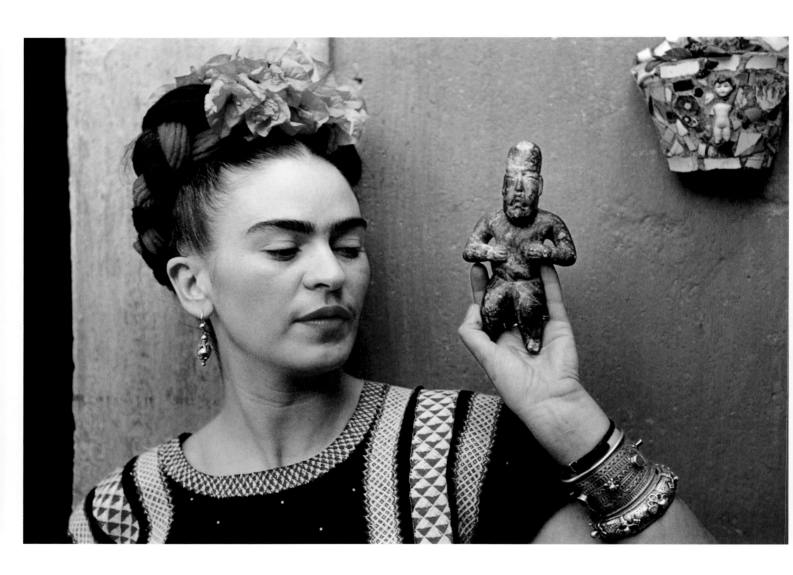

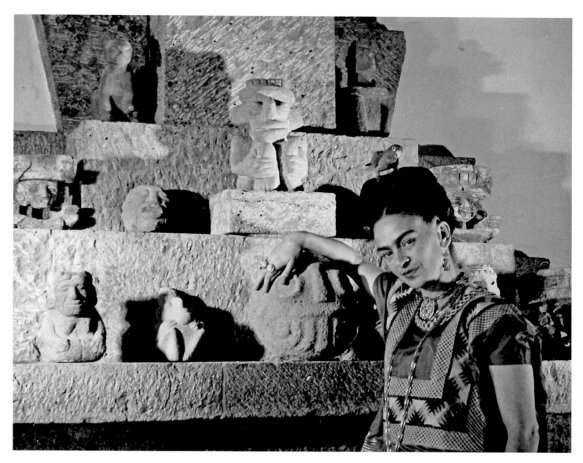

30.
Nickolas Muray
*Frida with Olmeca
Figurine, Coyoacán*, 1939
Print, 10¾ x 15¾ in.
(27.3 x 40 cm)
Fine Arts Museums of
San Francisco, Gift of
George and Marie Hecksher
in honor of the tenth
anniversary of the new
de Young Museum, 2018.68.1

31.
Unknown photographer
Frida Kahlo, Blue House,
Coyoacán, Mexico City,
ca. 1951
Gelatin silver print,
5⅝ x 4⅝ in.
(14.3 x 11.9 cm)
Vicente Wolf Collection

32.
Gisèle Freund
Frida Kahlo smoking
by figure in the courtyard
of La Casa Azul, ca. 1951
Gelatin silver print,
6¾ x 8¾ in. (17 x 22 cm)
The Hecksher Family
Collection

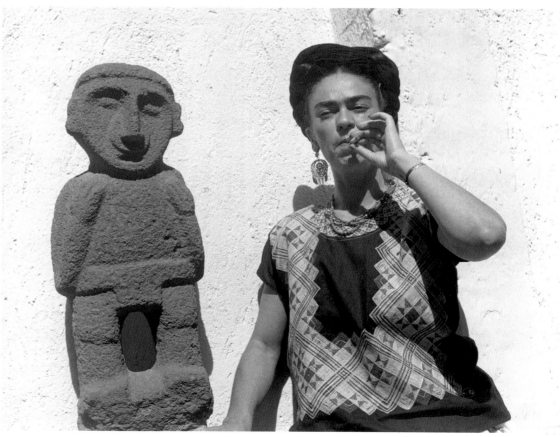

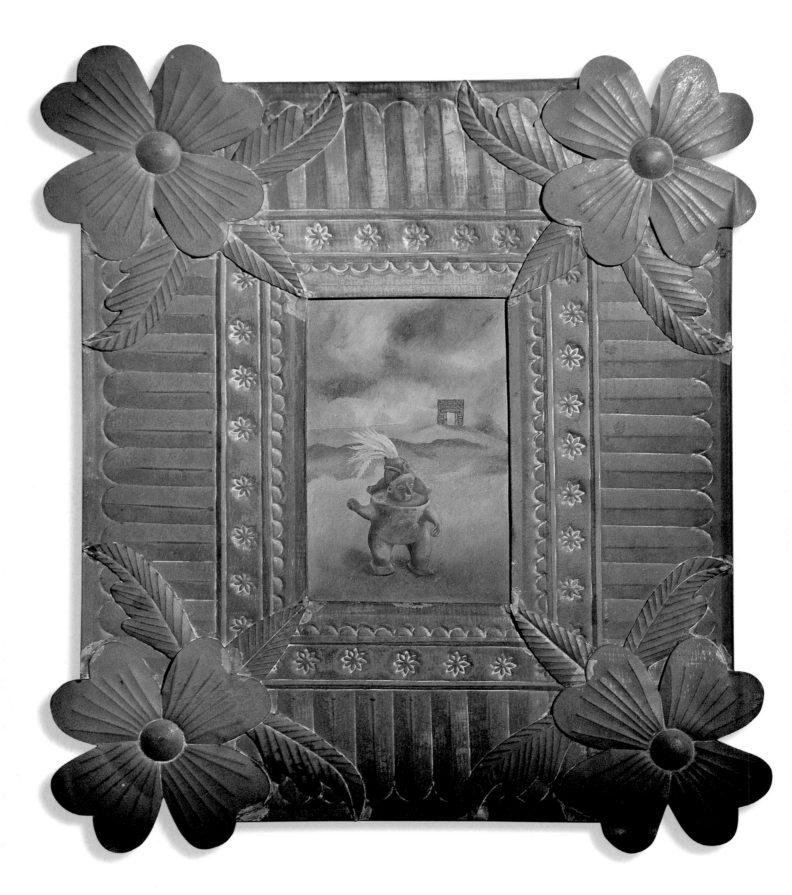

The painting bears the inscription:

Soy de Samuel Fastlicht.
Me pintó con todo cariño,
Frida Kahlo, en 1951.
~Coyoacán~

33.
Frida Kahlo
Survivor, 1938
Oil on metal,
6 ⅝ x 5 ¾ in.
(16.9 x 14.6 cm);
frame: 16 ⅞ x 14 ⅝ in.
(43 x 37.2 cm)
Pérez Simón Collection,
Mexico City

34.
Frida Kahlo
Still Life (I Belong to
Samuel Fastlicht), 1951
Oil on Masonite,
11 ¼ x 14 ⅛ in.
(28.6 x 35.9 cm)
Private collection;
courtesy of Galería
Arvil, Mexico City

El Universo
la tierra,
Diego y
yo.
El abrazo de
Amor.

35.
Frida Kahlo
*The Embrace of
Love*, 1949
Pencil on paper,
11¾ x 8⅝ in.
(29.8 x 21.9 cm)
Museo Frida Kahlo,
Mexico City

36.
Frida Kahlo
*The Love Embrace of
the Universe, The Earth
(Mexico), Diego, Me,
and Senor Xolotl*, 1949
Oil on canvas,
27½ x 23¾ in.
(69.8 x 60.3 cm)
Jacques and Natasha
Gelman Collection,
Mexico City

37.
Frida Kahlo
*Sketch of Self-Portrait
Painted for Stalin*, 1954
Pencil on paper,
11¾ x 8¾ in.
(29.9 x 22.3 cm)
Museo Frida Kahlo,
Mexico City

38.
Frida Kahlo
Stalin diary entry, n.d.
Museo Frida Kahlo,
Mexico City

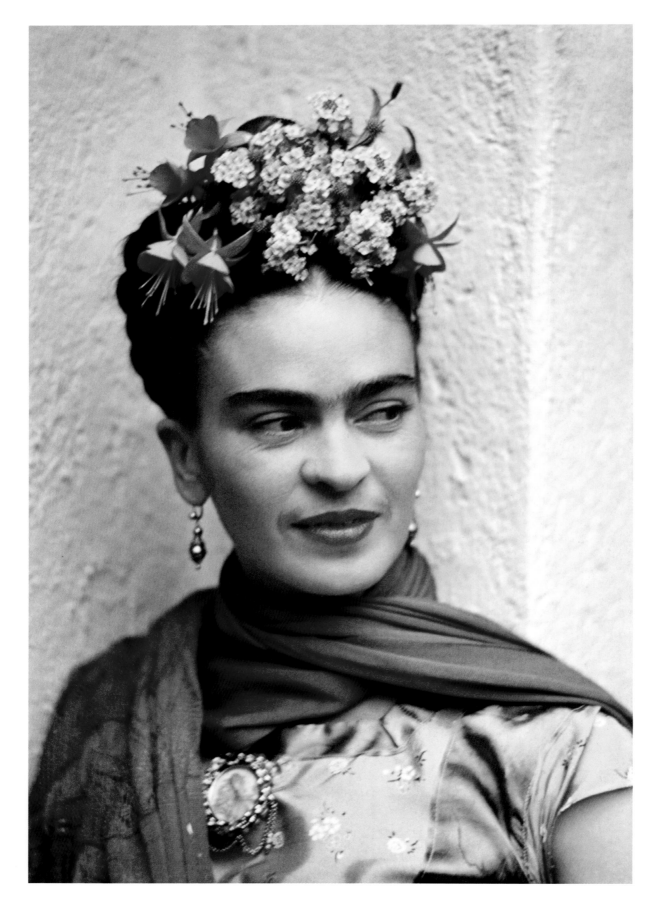

39.
Nickolas Muray
*Frida in Pink and Green
Dress, Coyoacán*, 1938
Inkjet print,
13¾ x 9½ in.
(34.8 x 24.1 cm)
The Hecksher
Family Collection

40.
Nickolas Muray
*Frida in a Blue
Satin Blouse,
New York City*, 1939
Inkjet print,
12⅝ x 9½ in.
(32 x 24 cm)
The Hecksher
Family Collection

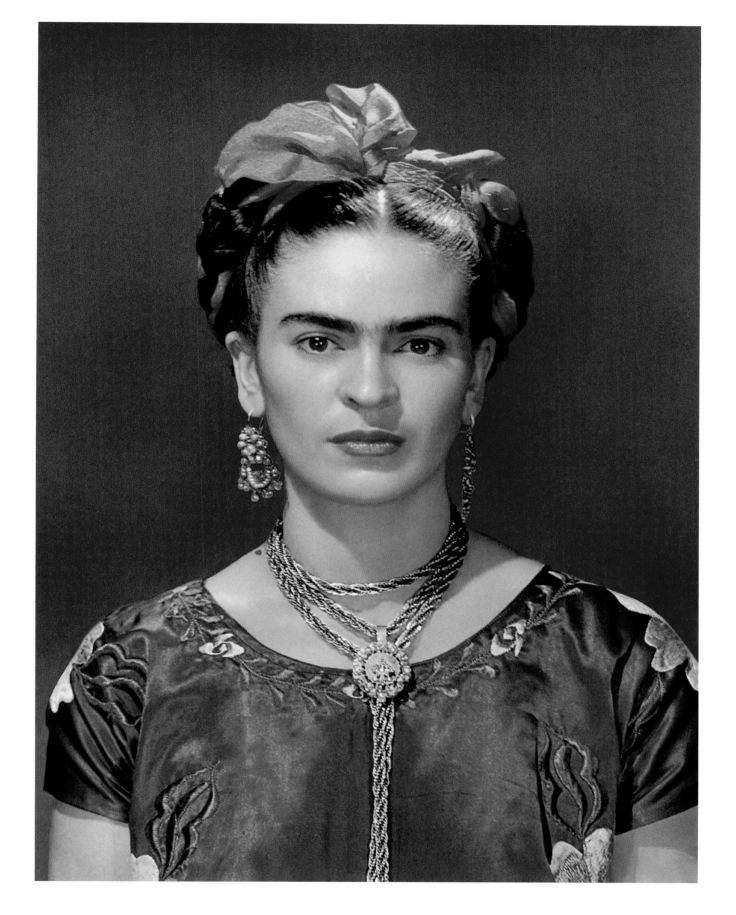

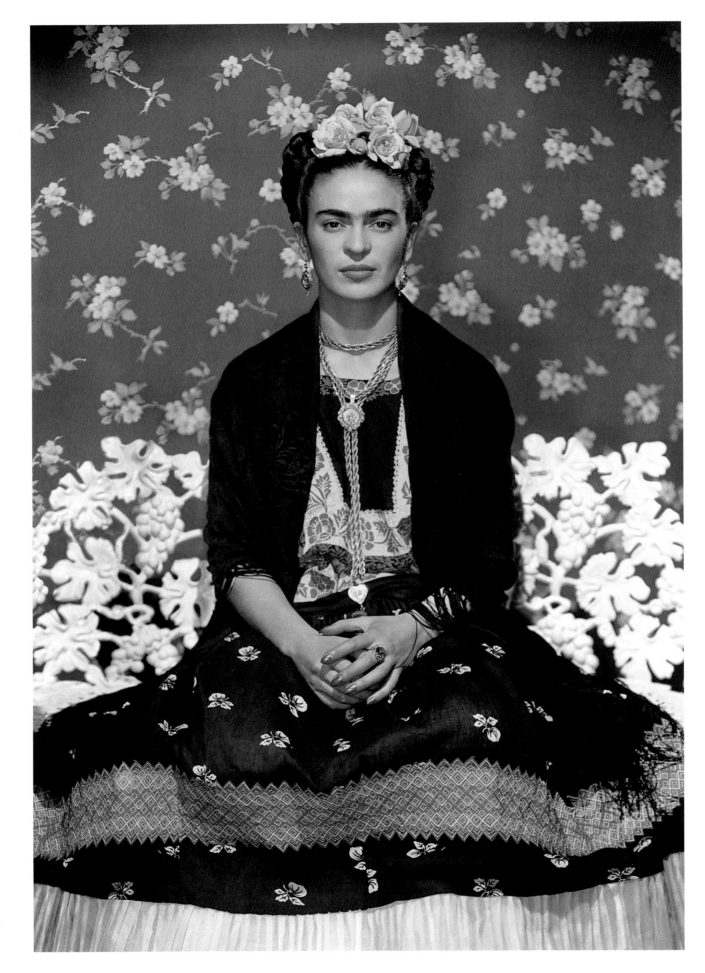

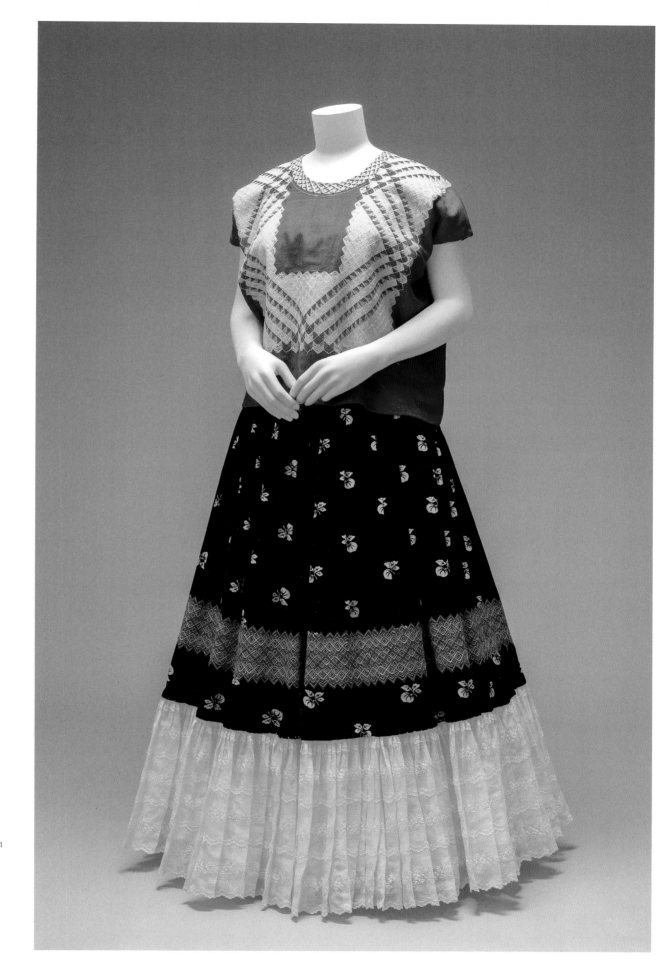

41.
Nickolas Muray
*Frida on White Bench,
New York,* 1939
Inkjet print, variable
dimensions
Nickolas Muray
Photo Archives

42.
Javier Hinojosa
Cotton *huipil* with
machine-embroidered
chain stitch, printed
cotton skirt with
embroidery and
holan (ruffle), before 1954
Banco de México, Diego
Rivera and Frida Kahlo
Trust, Mexico

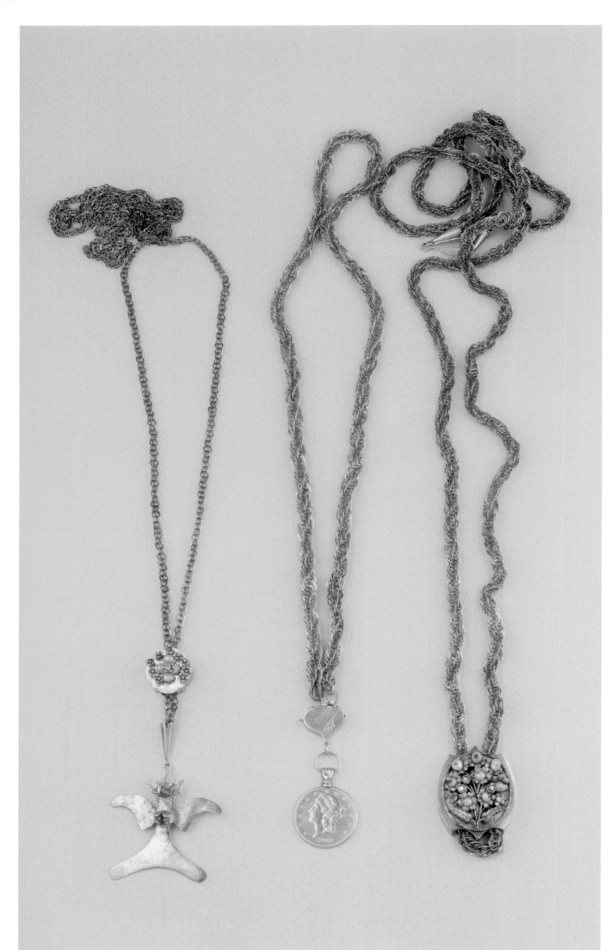

43.
Three *torzales* (chains)
Museo Frida Kahlo,
Mexico City

Left to right:

Necklace with
pre-Hispanic pendant
Pendant: Veraguas,
Panama, 700–1500
Necklace: probably
Campeche or Yucatán,
Mexico, before 1939
Gold and freshwater pearls

Necklace with 1903
twenty-dollar coin,
before 1939
Oaxaca, Mexico
Gold

Necklace with ornamental
slide, 1930–1939
Oaxaca, Mexico
Gold and freshwater pearls

44.
Frida Kahlo
Itzcuintli Dog and Me, 1938
Oil on canvas, 28 x 20½ in.
(71 x 52 cm)
Private collection

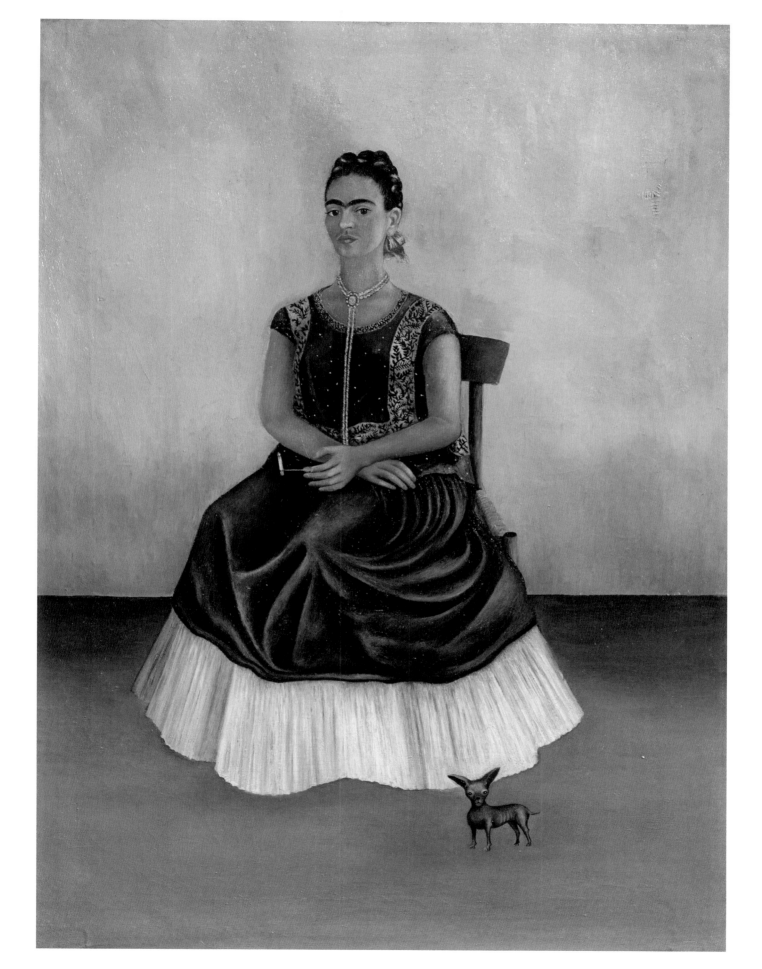

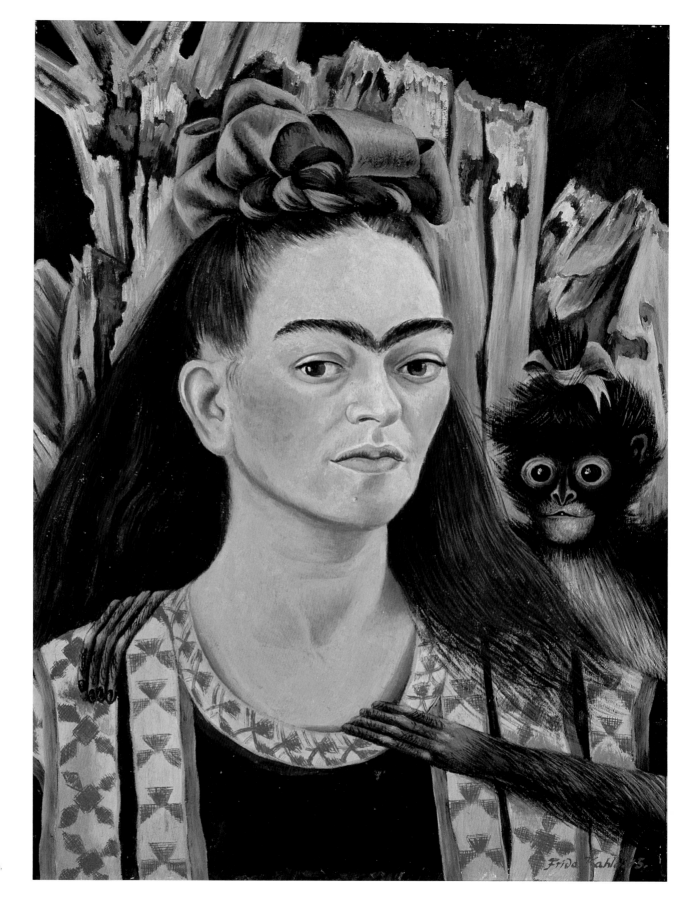

45.
Frida Kahlo
Self-Portrait with Monkey, 1945
Oil on wood,
23⅝ x 16¾ in.
(60 x 42.5 cm)
Robert Brady Museum,
Cuernavaca, Mexico

Acknowledgments

This publication *Frida Kahlo and San Francisco: Constructing Her Identity* has been published to celebrate the exhibition *Frida Kahlo: Appearances Can Be Deceiving* at the de Young in San Francisco. As this book describes, Frida Kahlo made two trips to the City by the Bay and was inspired by what she found there. It is therefore more than appropriate to share the show, which originated at the Museo Frida Kahlo in Mexico City and was later presented at the Victoria and Albert Museum in London, with Northern California audiences.

A presentation of this import would not be possible without the support of our gracious sponsors: John A. and Cynthia Fry Gunn, Diane B. Wilsey, The Bernard Osher Foundation, The Michael Taylor Trust, the Ray and Dagmar Dolby Family Fund, George and Marie Hecksher, and Alec and Gail Merriam. Additionally, we thank the following lenders who have entrusted us with their works of art: Collection of Gretchen and John Berggruen, San Francisco; Center for Creative Photography, University of Arizona, Tucson, Edward Weston Archive; Fundacíon FEMSA Collection, Monterrey, Mexico; Gobierno del Estado de Tlaxcala, Instituto Tlaxcalteca de Cultura, Mexico; The Hecksher Family Collection; Collection of Jan Hendrickx; Instituto Nacional de Antropología e Historia, Mexico; Museo Frida Kahlo, Mexico City; Nickolas Muray Photo Archives; Phoenix Art Museum; Coleccíon Juan Rafael Coronel Rivera; Robert Brady Museum, Cuernavaca, Mexico; San Francisco Museum of Modern Art; Coleccíon Pérez Simón, Mexico; Throckmorton Fine Art, New York; University of California San Francisco School of Medicine Dean's Office at Zuckerberg San Francisco General Hospital and Trauma Center; The Vincente Wolf Collection; private collection, courtesy of Galería Arvil, Mexico; private collection, courtesy of Sotheby's; and other private collections. And we are grateful to Amy Cappellazzo, Benjamin Doller, and George Wachter at Sotheby's, as well as Salomon Grimberg, for helping us to secure important loans from private collections.

At the Fine Arts Museums of San Francisco, we thank Thomas P. Campbell, director and CEO, for his vision to bring this presentation to the West Coast. His work was furthered by the Board of Trustees, led by Jason Moment, president, and Diane B. Wilsey, chair emerita. This project was championed and tirelessly supported by Krista Brugnara, director of exhibitions, who managed all of the underpinnings, with assistance from Christopher Busch, senior exhibitions designer; Shannon Stecher Anandasakaran, exhibitions manager; Caroline McCune, senior exhibitions coordinator; and Monique Abadilla, registrar. We acknowledge further staff for their behind-the-scenes support: Megan Bourne, chief of staff; Jason Seifer, director of finance and interim chief financial officer; Melissa E. Buron, director of the art division; Amanda Riley, director of development; Linda Butler, director of marketing, communications, and visitor experience; Sheila Pressley, director of education; and Stuart Hata, director of retail operations. A special callout is made to Christina Hellmich, curator in charge of the arts of Africa, Oceania, and Americas, for her advocacy at all levels.

This book was overseen by the Publications Department at the Museums, under the incredible stewardship of Leslie Dutcher, director of publications. Trina Enriquez, editor, gracefully edited the texts, and José Jovel, sought the rights and reproductions and assisted with the management of all parts of the making of this volume. Sue Grinols, director of photo services, and Randy Dodson, head photographer, helped with the imagery, along with Robert Carswell, digital assets and rights manager, who aided us at various intervals. We thank Yolanda de Montijo of Em Dash for her vibrant design, Rusty Sena and Carlos Rangel at Art Product LA for the beautiful prepress work, and Klaus Prokop at Dr. Cantz'sche Druckerei

Medien GmbH for the fine printing of this publication. We are also grateful to Elisabeth Rochau-Shalem and Rainer Arnold at Hirmer for their help to distribute this title in the trade. We further thank Vivian Constantinopoulos at Reaktion Books, London, for enabling us to share more of the story of Frida Kahlo in San Francisco that originated in their publication *Critical Lives: Frida Kahlo*.

We are immensely appreciative of our colleagues at the Museo Frida Kahlo, Mexico City, and the Bank of Mexico Trust. At the Trust, we acknowledge Jessica Serrano, director of financial education and cultural promotion, and Luis Rodrigo Saldaña, general trustee and legal manager. We are grateful to the Trust's Technical Committee, including its president Carlos García Ponce; and we express further thanks to general director of the Committee and of the Museos El Olmedo Frida Kahlo y Diego Rivera-Anahuacalli, Carlos Phillips Olmedo. We are appreciative of the Apoyo al Desarrollo de Archivos y Bibliotecas de México, A.C., and its president Isabel Grañen Porrúa. We also extend our gratitude to Alfredo Harp Helú. It is an honor to express our profound indebtedness to Hilda Trujillo, director of the Museos El Olmedo Frida Kahlo y Diego Rivera-Anahuacalli, for her enormous investment in the project from its inception— we could not have done it without her. Thanks also to other members of the staff at the Museo Frida Kahlo: Xochiquétzal González, Perla Labarthe, Luanda López, Maria Teresa Moya, Claudia Romo, and Laura Zavala. Our counterparts at the V&A were also tremendously supportive, including Susannah Priede, Emma Woodiwiss, and our dear friend and thought-partner, Claire Wilcox.

The research for this project, which has been conducted over the past decades, has yielded incredible primary source material that has informed the exhibition and this publication. In addition to various private collections in Mexico and the United States, we are indebted to the scholar Hayden Herrera; the archives at La Casa Azul, Mexico City; the archives at the National Museum of Women in the Arts, Washington, DC; the Syracuse University Libraries and University Archives, New York; the Library of Congress, Washington, DC; the Smithsonian American Art Museum, Washington, DC; and Brandeis University's Archives and Special Collections, Waltham, Massachusetts.

Special thanks are extended to our academic homes. Our colleagues at LASALLE College of the Arts, Singapore: Steve Dixon, president of the College of the Arts; Venka Purushothaman, provost; Nur Hidayah Abu Bakar, dean of the faculty of the Design department; Wolfgang Muench, dean of the Research and the Fashion team; and, last but not least, to the fabulous research assistant Daniela Monasterios-Tan for her remarkable contributions to this project. We are also deeply thankful for the encouragement and brilliance of the faculty, staff, and students at Brandeis University. We thank Susie and Fred Harburg and Kirsten Olson for their unwavering friendship and profound generosity.

Finally, we dedicate this publication to the memory of Zvi Ankori, Mario Alejandro Henestrosa, and Noris Henestrosa. Our gratitude is further given to other members of our families, including Ora Ankori; Dave Ellison; Aleph Henestrosa; Cassandra Henestrosa; Cibeles Henestrosa; Nahum Karlinsky; and Lee-Or, Laura, Roi, Nina, and Amir Adam for their steadfast support and unbounded love.

We close by honoring the tremendous spirit of Frida Kahlo, who has graced all of us with her incredible art and legacy.

—CIRCE HENESTROSA AND GANNIT ANKORI WITH HILLARY C. OLCOTT

This catalogue is published in 2020 by the Fine Arts Museums of San Francisco and Hirmer on the occasion of the exhibition *Frida Kahlo: Appearances Can Be Deceiving* at the de Young from March 21 to July 26, 2020.

The exhibition *Frida Kahlo: Appearances Can Be Deceiving* originated in the extensive investigation of Frida Kahlo's personal belongings found in trunks, wardrobes, drawers, bathrooms, and cellars of La Casa Azul that had remained closed for over fifty years before being exhibited for the first time at the Museo Frida Kahlo (2012–2014) and later presented at the V&A London.

Presenting Sponsors
John A. and Cynthia Fry Gunn
Diane B. Wilsey

Major Support
The Bernard Osher Foundation
The Michael Taylor Trust

Significant Support
Ray and Dagmar Dolby Family Fund

Generous Support
George and Marie Hecksher

Additional support is provided by Alec and Gail Merriam.

The Museo Frida Kahlo thanks the Banco de México Trust, including Jessica Serrano, director of financial education and cultural promotion, and Luis Rodrigo Saldaña, general trustee and legal manager; its Technical Committee and its president Carlos García Ponce; general director Carlos Phillips Olmedo; ADABI and its president Isabel Grañen Porrúa; Mr. Alfredo Harp Helú; and Hilda Trujillo, Perla Labarthe, Laura Zavala, Xochiquétzal González, Claudia Romo, Luanda López, Circe Henestrosa, and the researchers who participated. With special thanks to the Instituto Nacional de Bellas Artes y Literatura and the Instituto Nacional de Antropología e Historia.

"Frida Kahlo in San Francisco" is repurposed from Gannit Ankori, *Critical Lives: Frida Kahlo*. London: Reaktion Books Ltd., 2013, repr. 2018.

ISBN: 978-3-7774-3573-2
Library of Congress Cataloguing in Publication Control Number: 2020931131

Fine Arts Museums of San Francisco
de Young, Golden Gate Park
50 Hagiwara Tea Garden Drive
San Francisco, CA 94118-4502
www.famsf.org

Leslie Dutcher, Director of Publications
Nikki Bazar, Editor
Lesley Bruynesteyn, Editor
Trina Enriquez, Editor
Victoria Gannon, Editor
José Jovel, Publications Associate
Barbara Morucci, Editorial Assistant

Project management by Leslie Dutcher with José Jovel
Edited by Trina Enriquez
Proofread by Susan Richmond with Lesley Bruynesteyn
Picture research by José Jovel
Designed and typeset by Yolanda de Montijo, Em Dash
Color separations by Rusty Sena, Artproduct, Los Angeles
Printing and binding by Dr. Cantz'sche Druckerei Medien GmbH, Germany

Published in association with
Hirmer Verlag GmbH
Bayerstraße 57–59
80335 Munich
Germany
www.hirmerpublishers.com

Picture Credits